COLLINS

Artist's
Guide to
Watercolour

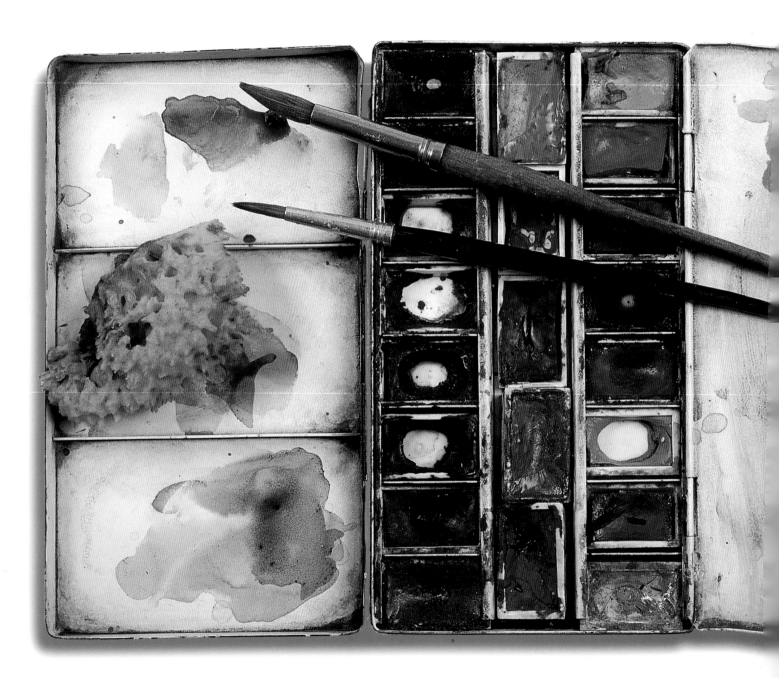

COLLINS

Artist's
Guide to
Watercolour

CONSULTANT EDITOR ANGELA GAIR

HarperCollins*Publishers*

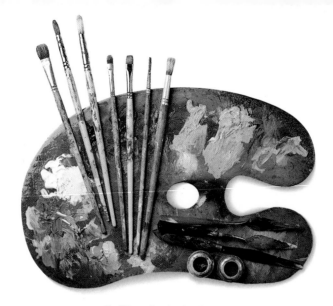

Collins Artist's Guide
WATERCOLOUR
Produced, edited and designed at Inklink,
Greenwich, London, England

Text and consultant editor: Angela Gair
Concept and art direction: Simon Jennings

Text editor: Albert Jackson

Illustrators: Robin Harris and David Day

Studio photography: Paul Chave

For HarperCollins:
Editorial director: Cathy Gosling
Senior production manager: Bridget Scanlon

**First published in 1997 by
HarperCollins Publishers, London
Copyright © HarperCollins Publishers, 1995, 1997
Reprinted 1998**

A CIP catalogue record for this book is available
from the British Library
ISBN 0 00 413310 2

Text set in Galliard and Univers Condensed
by Inklink, London
Colour origination by Colourscan, Singapore
Printed in Hong Kong by Sing Cheong Printing Co. Ltd.

Jacket design: Simon Jennings
Jacket photographs: Paul Chave

Most of the text and illustrations in this book were previously published in
Collins Artist's Manual

The editors of the COLLINS ARTIST'S GUIDE TO WATERCOLOUR are indebted to the following contributors who generously loaned samples of materials, artworks and transparencies, and who provided much time, advice and assistance.

CONSULTANTS

Trevor Chamberlain,
ROI, RSMA
David Curtis,
ROI, RSMA

John Denahy, NEAC
Ken Howard,
RA, ROI, RWS, NEAC
John Lloyd, technical adviser, Daler-Rowney
Terry McKivragan
John Martin
Ian Rowlands
Brian Yale
Emma Pearce, technical adviser, Winsor & Newton

Daler-Rowney Ltd,
for the use of the majority of art materials used in the demonstrations and photographs.

CONTENTS

WATERCOLOUR

ARTISTS
Penny Anstice
Richard Bell
John Blockley
Hercules B. Brabazon (1821-1906),
[Courtesy, Chris Beetles Gallery, London]
Jane Camp
[Courtesy, Westcott Gallery, Dorking]
Rosemary Carruthers
[Courtesy, Llewellyn Alexander Gallery, London]
Trevor Chamberlain
David Day
William Dealtry
[Courtesy, Brian Sinfield Gallery, Burford, Oxe
Geraldine Girvan
[Courtesy, Chris Beetles Gallery, London]
Roy Hammond
[Courtesy, Chris Beetles Gallery, I
Ken Howard
Simon Jennings
Ronald Jesty
Sally Keir
Sophie Knight
John Lidzey
John Martin
Alex McKibbin
Patrick Procktor
[Courtesy, Redfern Gallery, London]
Penny Quested
Jacqueline Rizvi
Hans Schwarz
J.M.W. Turner (1775-1851)
[Courtesy, Tate Gallery, London]
David Tindle
[Courtesy, Fischer Fine Art, Lond
Robert Tilling
Shirley Trevena
Anna Wood
Leslie Worth
Brian Yale
Rosemary Young

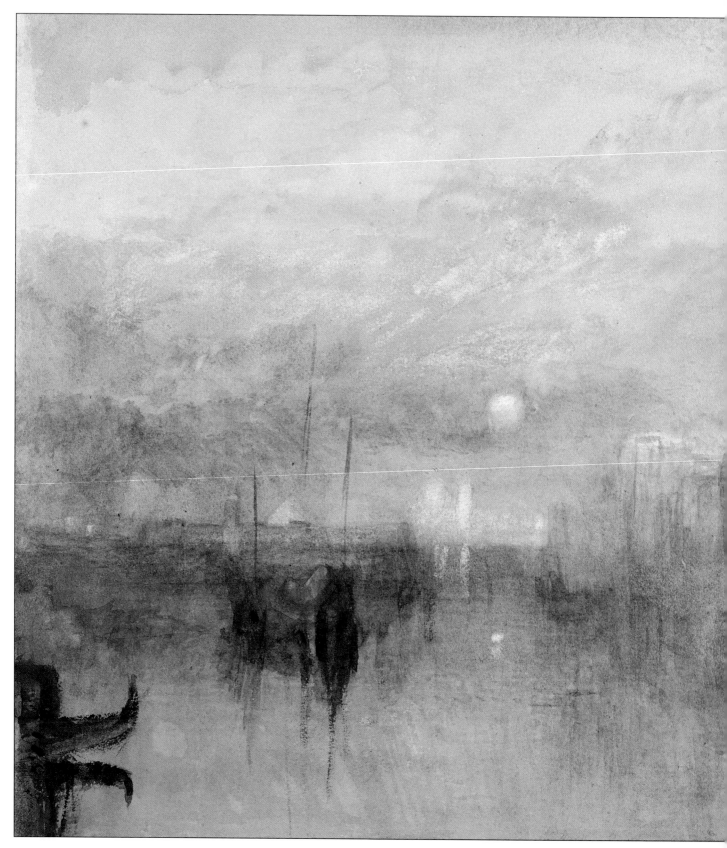

J. M. W. Turner (1775-1851) Venice Suburb, Moonlight, 1821 [detail]
Watercolour on paper 22 x 31.9cm (8¾ x 12¾in) Tate Gallery, London

WATERCOLOUR

WATERCOLOUR has a delicacy and transparency that makes it the perfect medium for capturing the subtle nuances of light and colour in nature. Because the paint is transparent, the white reflective surface of the paper shines through the colours, and gives them their unique luminosity.

The fluid nature of watercolour makes it less predictable than other painting media, but this is more than compensated for by the range of exciting and beautiful effects it can create – sometimes more by accident than design. The element of chance and risk can make watercolour a frustrating medium, as well as an exciting and challenging one. However, armed with the right equipment – and a basic understanding of how pigments, water and paper interact – you can stay one step ahead of the game.

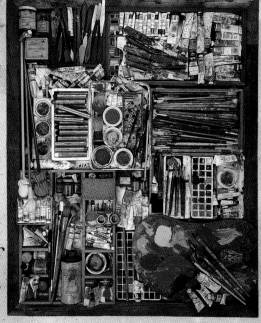

PAINTS

Paints for watercolour consist of very finely ground pigments bound with gum-arabic solution. The gum enables paint to be heavily diluted with water to make thin, transparent washes of colour, without losing adhesion to the support. Glycerine is added to the mixture to improve solubility and prevent paint cracking, along with a wetting agent, such as ox gall, to ensure an even flow of paint across paper.

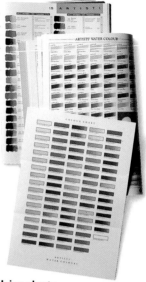

CHOOSING AND BUYING PAINTS

It is natural to assume that there is little difference in formulation between one brand of paint and another. In reality, the types and proportions of ingredients used by manufacturers do differ, so there are often variations in consistency, colour strength, handling qualities, and even permanence between one paint range and another.

It is worth trying out several brands of paint initially, as you may find that one suits your style of working better than another. You don't have to stick to one brand, however; good-quality watercolour paints are compatible across the ranges, and you may discover that certain individual colours perform better in one range than another. Viridian is a good example: in some brands it has a tendency to be gritty, while in other ranges it is perfectly smooth and clear.

• Differences between brands
Colours that are mixtures of pigments (sap green and Payne's gray, for example) show a marked variation in hue between brands because they are formulated differently, so do not expect a familiar colour name to be exactly the same colour in a different brand.

Using charts
When purchasing paints, don't depend on manufacturers' colour charts as a guide to a colour's appearance. Most are printed with inks that are not accurate representations of the colours. Handmade tint charts produced with actual paint on swatches of watercolour paper are more reliable; any reputable art supplier should have one which you can refer to.

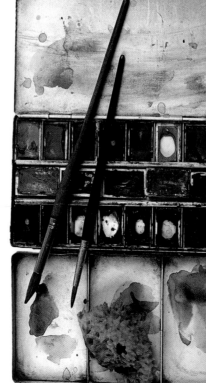

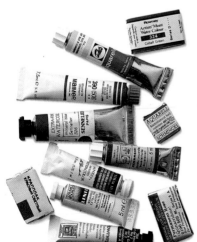

A selection of pans, half pans and tubes

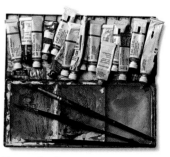

Types of paint
Watercolours are available in two main forms: as small, compressed blocks of colour, called 'pans' or 'half pans' according to size, and as moist colour in tubes. The formulations of tube and pan colours are very similar, and which type you choose is a matter of personal preference. Good-quality watercolour equipment will repay you with many years' loyal service.

PANS AND HALF PANS

These slot neatly into tailor-made, enamelled-metal boxes with recesses to hold them in place and separate them, and a lid that doubles as a palette when opened out. You can either buy boxes containing a range of preselected colours or, preferably, fill an empty box with your own choice. Colour is released by stroking with a wet brush; the wetter the brush, the lighter the tone obtained.

Pans are light and easy to use when painting out of doors. The colours are always in the same position in the box when you want them, and they don't leak. They are also economical to use, with minimal wastage of paint. However, it takes a little effort to lift enough colour onto the brush. Paints also become dirtied when you dart from one to the other without rinsing out your brush in between.

Care of pans

New pans tend to stick to the inside of the lid when you close the box; when you next open the lid, they may scatter out of order. It is good practice to remove excess moisture from pans with a damp sponge after a painting session. Leave the box open in a warm room for a few hours to let the colours dry off before closing the lid, and dry the palette on the inside of the lid before closing it, or the paints absorb the moisture and become sticky.

When using pan colours for the first time, wet them with a drop of water and leave until the water has been absorbed. This will ensure easier paint release when the pans are stroked with the brush.

Pans and half pans

Preventing lids sticking
After a painting session, remove excess moisture from pan colours with a damp sponge.

TUBES

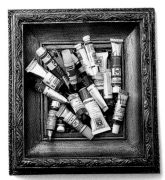

Standard tube sizes

Tubes of colour are available in sizes ranging from 5 to 20ml (0.17 to 0.66 US fl. oz), the standard size being 15ml (0.5 US fl. oz). The smaller sizes are designed to fit into travelling watercolour boxes, but the bigger tubes are more economical for large-scale work. Tubes can be bought singly or in preselected sets. Choosing your own tubes means you can obtain precisely the colours you need.

Tube colours are more cumbersome than pans when painting out of doors, but they are more suitable for large-scale work in the studio. Because tube paint is more fluid than the equivalent pan form, it is better for mixing large amounts of paint. Tubes can be more wasteful than pan colours, however, because it is easy to squeeze out more than you need, and paint can leak and solidify if the cap is not replaced properly. Tube colour is also prone to settling, as old stock may harden or separate in the tube.

Care of tubes

Always clean the tube thread before replacing a cap, or it may stick – the gum arabic in the paint acts as a glue. Stuck caps can be opened with pliers, or by holding the tube under a hot tap so that the cap expands and is easier to remove. Do not throw away tubes of hard paint, as it is often possible to salvage the contents (see right).

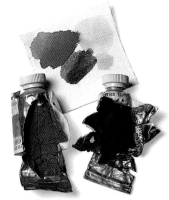

Improvised pans
Always replace caps of tube colours immediately, otherwise the paint will harden in the tube. If this does happen, however, cut open the tube and use it as an improvised pan. So long as the paint is not so old that the gum-arabic binder has become insoluble, it should be possible to reconstitute the paint with water.

Salvaging tubes
It is possible to bring dried-up tube paint back to its former paste-like consistency. Unroll the tube, cut the end off, and add a few drops of water. Let the hardened paint absorb the moisture, and rework it back to a paste.

GRADES OF PAINT

There are two grades of watercolour paint: artists' (first quality) and students' (second quality). Although student-grade oil paints can be recommended for beginners wishing to experiment without breaking the bank, student-grade watercolours are usually a false economy because they lack some of the subtlety and transparency of first-quality paints. Artist-quality paints are more expensive, but they are worth it and, besides, you don't need a truckload of paints in order to produce a good painting.

Having said this, reputable paint manufacturers go to great lengths to maintain high standards at an economic price, and some artists find students' colours perfectly acceptable for everyday use. Certain student-grade colours may even have particular qualities which you prefer over the artists' equivalent. For example, if you want a bright green, you may find a mixture of student-grade cobalt blue and cadmium yellow better than the subtle green produced by the same mixture in artists' colours.

Students v. Artists
Mixing student-grade cobalt blue and cadmium yellow may give you a brighter colour than that achieved by the same mixture in artists' colours.

ARTISTS' PAINTS

Artist-quality paints contain a high proportion of good-quality, very finely ground, permanent pigments. The colours are transparent and luminous, they mix well, and there is a wide range. Paints are often classified by 'series', usually from 1 to 5, according to the availability and cost of the pigments. Generally, series 5 pigments are the most costly, and series 1 the least.

STUDENTS' PAINTS

Student-quality paints are usually labelled with a trade name, such as 'Cotman' (Winsor & Newton) or 'Georgian' (Daler-Rowney), and should not be confused with the very cheap paints imported from the Far East, which should be avoided.

Students' paints are sold at a uniform price, offering the beginner an affordable selection of colours. They contain less pure pigment and more fillers and extenders; many of the more expensive pigments, such as the cadmiums and cobalts, are substituted by cheaper alternatives. Such substitution is commonly indicated by the word 'hue' after the pigment name. The selection of colours is usually smaller than that of artists' ranges.

Permanence

Watercolour is as permanent as any other medium, provided that permanent colours are used. Always check the manufacturer's permanency rating, which is printed either on the tube label or in their catalogue. It is also important to use acid-free paper, and to protect watercolour paintings from bright sunlight. An interesting experiment is to paint a patch of colour onto paper, cover half with a piece of card and place it in bright, indirect light for several weeks. When you remove the card, you can judge the colour loss. Most good-quality paints show little or no fading.

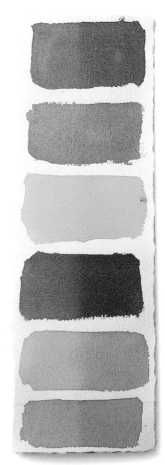

Testing colour permanence
This colour chart of student-quality watercolours was left taped to a window and exposed to northern light for four months. The effects of fading can be clearly seen.

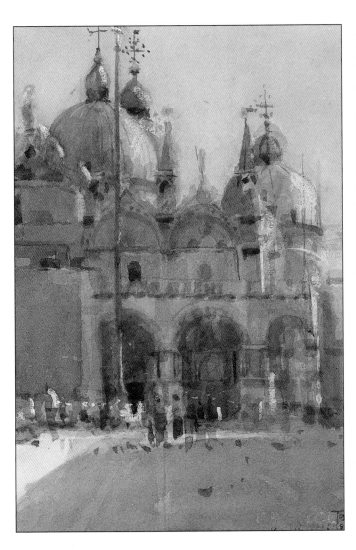

Ken Howard
(left)
SAN MARCO, MORNING
Watercolour on paper
27.5 x 22.5cm (11 x 9in)

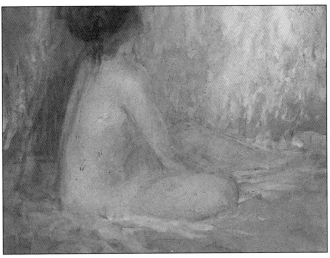

Jacqueline Rizvi
DANAE
Watercolour on paper
27.5 x 21.2cm (11 x 8½in)

Alex McKibbin
(below)
ENVIRONS OF PAMAJERA
Watercolour on paper
55 x 75cm (22 x 30in)

Transparency of colour
Three ways of using the unique transparency of pure water-colour, which gives a luminous glow unmatched by other media.

Ken Howard (above left) has captured the haze of early-morning sunlight on St Mark's, Venice, with thin veils of shimmering colour, applied one over the other.

Jacqueline Rizvi (above) uses watercolour mixed with Chinese white and applies translucent layers of colour very gradually, using fairly dry paint. This delicate and unusual technique maintains the transparent, atmospheric quality of watercolour while giving it a more substantial texture. This study is worked on brown Japanese paper, which provides an underlying warm tone.

Alex McKibbin's aim (left) is always to capture the pulse and energy of nature, and to this end he manipulates brush, pigments and water with great bravura, alternating crisp strokes and drybrush with softer areas. The white surface of the paper plays an integral part, reflecting light through the thin layers of colour.

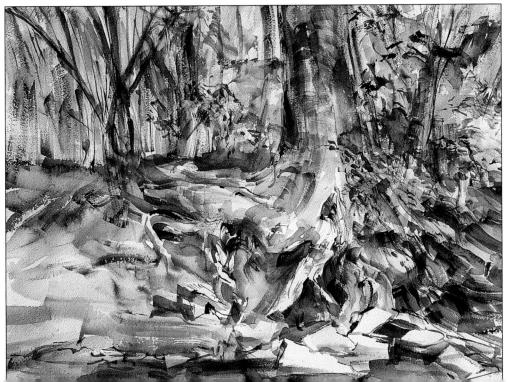

PIGMENT AND COLOUR

Although watercolour is regarded as a 'transparent' medium, pigments fall into three groups: transparent, opaque and staining. The characteristics of each group depend on the substances from which they are derived. Additionally, some colours are intense and have greater tinting strength than others.

The list below shows the characteristics of some popular colours. However, brands of paint vary widely in their formulation; therefore, test the colours yourself.

TRANSPARENT PIGMENTS Highly transparent colours permit the white reflective surface of paper to shine through. They have an attractive, airy quality which is perfect for capturing the illusion of atmosphere, space and light. Some transparent colours are also strong stainers (see below), though this will not concern you unless you wish to lift out colours.

OPAQUE PIGMENTS In watercolour, so-called 'opaque' colours are obviously far more transparent than they are in oils, particularly when they are thinly diluted. Many opaque pigments are brilliant, while others are beautifully subtle. However, these pigments impart a degree of opacity to all colours they are mixed with – if used carelessly, they create cloudy colours lacking brilliance and luminosity.

STAINING PIGMENTS Some transparent colours, such as alizarin crimson, are highly staining: they penetrate paper fibres and cannot be removed without leaving a trace of colour. Some earth colours, cadmiums and modern organic pigments also tend to stain; if you intend to 'lift' or sponge out areas of colour, choose non-staining pigments where possible.

TINTING STRENGTHS The tinting strength of pigments varies considerably. Some are very strong and overpower in mixtures, so only a small amount is needed. Others are so delicate you must use a large amount to make an impact on another colour. Knowing how strong or weak each colour is will save you a lot of time and frustration when mixing colours together.

Transparent non-staining

	French ultramarine
	Cobalt blue
	Rose madder genuine
	Aureolin
	Hooker's green
	Raw sienna
	Payne's gray

Transparent staining

	Winsor red, blue and green
	Scarlet lake
	Alizarin crimson
	Viridian
	Sap green
	Prussian blue
	Gamboge

Opaque

	All cadmium colours (cadmium red shown)
	Indian red
	Yellow ochre
	Burnt umber
	Davy's grey
	Cerulean blue
	Lemon yellow
	Raw umber
	Chrome oxide green

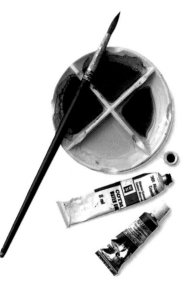

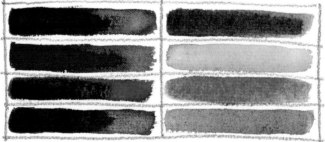

Strong tints
Colours such as alizarin crimson, cadmium red, phthalocyanine blue and burnt sienna are very strong, and need to be diluted heavily.

Low-strength tints
Pigments with a low tinting strength include raw umber, yellow ochre, cerulean blue and raw sienna.

COLOUR MIXING

Cobalt blue
Wet paint (above) compared with a dry example (below).

Always mix more paint than you think you will need; it is surprising how quickly it is used up. It is frustrating to run out of colour halfway through a wash and then have to try to remix the exact colour again.

One of the keys to good colour is to restrain yourself from mixing pigments too much. If you are blending two colours together, for example, the mixture should show three: the two original pigments and the mixture itself. This gives a livelier vibration to the colour.

Another way to ensure that you don't overmix your colours is to apply each one separately, mixing directly on the support. Colours may be applied in successive glazes (wet-on-dry), or allowed to blend on dampened paper (wet-in-wet).

TRIAL AND ERROR

You cannot tell by looking at paint on a palette whether you have achieved the right colour or tone: the colour must be seen on paper.

Watercolour paint always dries lighter on paper than it appears when wet (see left), so mixing is often a matter of trial and error. When mixing, therefore, it is useful to have a piece of spare paper to hand for testing the colours before applying them to a painting.

> '*ONE MAKES USE OF PIGMENTS, BUT ONE PAINTS WITH FEELING.*'
>
> JEAN-BAPTISTE CHARDIN
> (1699-1779)

Mixing
Pigments should not be mixed too much. Stop mixing while you can still see the original colours along with the mixture. The lightly mixed examples (below, **2** and **3**) can be seen to be more lively and colourful than the overmixed example (**1**).

1 French ultramarine and alizarin crimson overmixed on the palette.

2 The same colours, this time partly mixed on the palette.

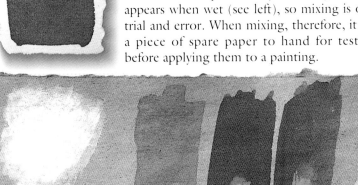

Semi-transparent colours
One way of using Chinese white is to dilute it and mix it directly with transparent colours. This gives a semi-transparent, slightly milky effect that is particularly effective on toned papers.

USING BODY COLOUR

Chinese white
A cool white, ideal for tinting other colours.

To purists, the use of opaque paint in a watercolour is nothing short of heresy. A watercolour is supposed to be transparent, they would say, and paler tones are achieved by adding more water to paint, while pure white areas are achieved by reserving areas of white paper. However, most watercolourists take a more pragmatic approach and use opaque paint when it seems appropriate for a particular stage in a painting – when creating highlights, for example.

Transparent watercolours can be rendered opaque or semi-opaque by mixing them with Chinese white to produce what is called body colour. Chinese white is a blend of zinc-oxide pigment and gum arabic; it is a dense, cool white which produces pastel tints in mixtures due to its high tinting strength.

3 The same colours partly mixed on wet watercolour paper.

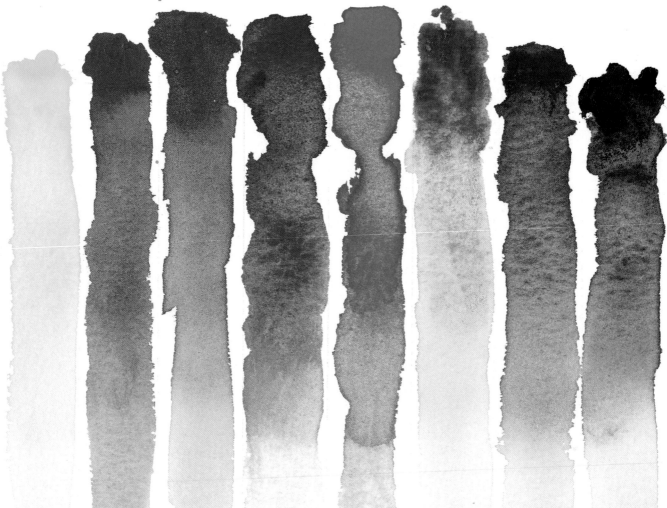

BASIC PALETTES

The enormous range of pigments available makes it difficult to choose colours in a considered way. Who can resist those endless rows of gorgeous colours in the local art store? Sets of good-quality watercolours are available in boxes, but these are expensive and may contain far more colours than you need. A wiser course is to buy an empty box and fill it with colours of your own choice.

Starter palette

The ASTM (American Society for Testing and Materials) codes for lightfastness:

ASTM I – excellent lightfastness
ASTM II – very good lightfastness
ASTM III – not sufficiently lightfast

Cadmium yellow
Permanence excellent (ASTM I). An opaque colour with a warm and orange-yellow hue. Very clear and bright.

Cadmium red
Permanence excellent (ASTM I). An opaque colour with a bright vermilion tone. Very clear and bright.

Permanent rose
Permanence good (ASTM II). A transparent colour with a cool pinkish-red hue. A softer and more permanent alternative to alizarin crimson.

French ultramarine
Permanence excellent (ASTM I). An excellent transparent colour with a deep blue, violet-tinged hue. Makes a range of subtle greens when mixed with yellows.

Cobalt blue
Permanence excellent (ASTM I). A transparent colour with a soft blue hue. Cooler than French ultramarine.

Raw sienna
Permanence excellent (ASTM I). A transparent colour, excellent for layering washes, with a deep golden-yellow hue. A very lightfast and durable colour.

Burnt sienna
Permanence excellent (ASTM I). A transparent colour with a deep red-brown hue. Mixes well with other pigments, giving muted and subtle colours.

Burnt umber
Permanence excellent (ASTM I). A more transparent colour than raw umber, with a warm brown hue. Excellent in mixtures of pigments.

Auxiliary palette

Preselected boxes

This typical shop-bought watercolour-pan box (right) contains the following colours:

Cadmium yellow pale

Cadmium red

Alizarin scarlet

Alizarin crimson

Viridian

Burnt umber

Yellow ochre

Burnt sienna

Light red

French ultramarine

Prussian blue

Ivory black

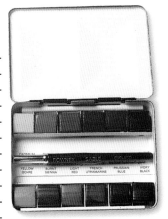

Auxiliary palette

The seven colours shown below have been chosen as a range that will extend your choices for watercolour painting. Apart from the possibilities they provide for further mixing and experimentation, you will find them very useful when painting outdoors, particularly for landscapes.

Cerulean blue
Permanence excellent (ASTM I).
A semi-transparent colour with a cool and greenish-blue hue.
Ideal for painting skies.

Phthalocyanine blue
Permanence good (ASTM II).
A transparent colour with a deep, intense blue hue and a cold, sharp tone.
A strong staining colour.

Cobalt violet
Permanence excellent (ASTM I).
A transparent colour with a bright, red-violet hue.
A pure violet that cannot be mixed or imitated.

Raw umber
Permanence excellent (ASTM I).
A transparent colour with a greenish-brown hue.
Useful in mixes.

Yellow ochre
Permanence excellent (ASTM I).
A transparent colour with a soft golden-yellow hue.
Has a calming effect on other colours.

Viridian
Permanence excellent (ASTM I).
A transparent colour with a cool bluish-green hue.
Makes a good basis for warm, bright greens.

Venetian red
Permanence excellent (ASTM I).
A semi-opaque colour with a warm terracotta-red hue.
Very useful for mixing flesh tones.

15

BRUSHES

Brushes are a very important element in watercolour painting, so it is worth buying the best quality you can afford. Cheap brushes are a false economy, as they do not perform well and quickly wear out.

A GOOD BRUSH

A good brush should have a generous 'belly' capable of holding plenty of colour, yet releasing paint slowly and evenly. The brush should also point or edge well – when loaded with water, it should return to its original shape at the flick of the wrist. The best brushes have a seamless ferrule made of cupro-plated nickel, which is strong and resistant to corrosion. Lower-grade brushes may have a plated ferrule with a wrapover join; with repeated use this may tarnish or open up.

• Bristles
The bristles should point well. When loaded with water, they should return to their original shape.

SABLE

Sable hair is obtained from the tail of the sable marten, a relative of the mink. Sable brushes are undoubtedly the best choice for watercolour painting. They are expensive, sometimes alarmingly so, but they give the best results and, if cared for well, will last a lifetime. Sable hair tapers naturally to a fine point, so that brushes made from it have very delicate and precise tips which offer maximum control when painting details. Good-quality sable brushes are resilient yet responsive; they hold their shape well and do not shed their hairs, and have a spring and flexibility which produce lively, yet controlled brushstrokes.

• Belly
This should hold a lot of colour, and release the paint slowly and evenly.

• Ferrule
A seamless, cupro-plated nickel ferrule is strong and will not corrode.

Kolinsky sable
The very best sable is Kolinsky sable; it comes from the Kolinsky region of northern Siberia, where the harshness of the climate produces hair that is immensely strong, yet both supple and springy.

Red sable and pure sable
Brushes marked 'red sable' or 'pure sable' are made from selected non-Kolinsky hair. They do not have quite the spring and shape of Kolinsky, but are perfectly adequate and more moderately priced. However, beware of buying very cheap sable brushes just because they carry the name 'sable' – good-quality sable is springy and strong, while being at the same time fine and soft.

• Handle
This should be lacquered against water, chipping or cracking, and be comfortable in use. Size, series, and type are embossed on the handle.

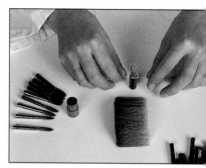

Brush making
Even today, brush making is largely a hand-skill process utilizing traditional components and natural materials (see bottom right).

Portable brushes
Small retractable brushes, with a 'travelling' set of pans, are ideal for making sketches when painting out of doors.

SQUIRREL HAIR This is dark brown in colour, and is much softer than sable. Although at first sight much cheaper than sable, squirrel-hair brushes are generally a false economy, as they do not point well and have little resilience. Squirrel-hair 'mop' brushes, however, retain a large amount of colour, allowing extensive washes to be laid quickly and evenly. This makes them an economical alternative to large-size sable wash brushes.

OX HAIR This hair comes from the ear of a breed of cow and is strong and springy, but quite coarse. It does not point very well and is not suitable for making fine-pointed brushes, but it is a very good hair for use in square-cut brushes. Ox-hair brushes usually have a long hair-length, which increases their flexibility.

GOAT HAIR A type of hair often used in traditional Oriental watercolour brushes. The hair is soft but sturdy, and goat-hair brushes hold a lot of water. This makes them ideal for laying broad washes and for working wet-in-wet.

SYNTHETIC FIBRES These have been introduced in an attempt to achieve the performance of natural hair at a cheaper price. Sable-type synthetics are a golden-yellow colour, and are made from polyester filaments with tapered ends which imitate the real thing. They can be a little stiff and unsympathetic in comparison to natural hair, and have less colour-holding capacity, but synthetics in smaller sizes are a better choice for fine work than, say, squirrel hair.

COMBINATION BRUSHES Some manufacturers offer brushes which combine synthetic hair with real sable, to achieve good colour-holding and pointing properties at a reasonable cost.

Components and materials used in brushmaking

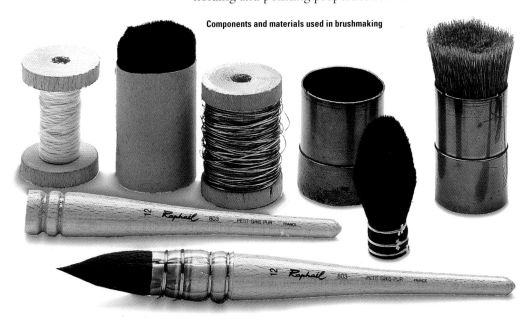

Quick guide to watercolour-brush hair

Kolinsky sable
The best: very expensive, immensely strong, yet supple and springy.

Red or pure sable
More moderately priced, springy and strong, yet fine and soft.

Squirrel hair
Softer and cheaper than sable, this does not point well and has little resilience. A less-costly alternative to large-size sable wash brushes.

Ox hair
Strong and springy, but quite coarse, it does not point very well. Good hair for square-cut brushes.

Goat hair
Soft but sturdy, ideal for laying broad washes.

Synthetic fibres
These can be a little stiff and unsympathetic, with less colour-holding capacity than animal hair.

Combination hair
The brush shown is a combination of squirrel and goat hair. Other blends of animal hairs are available, as are animal-synthetic combinations.

BRUSH SHAPES & SIZES

*Art-supply stores and manufacturers'
catalogues offer a wide range of variations on
watercolour brushes, but those detailed below
will provide all you need for successful
watercolour painting.*

ROUND BRUSHES

The round is perhaps the most useful and most common brush shape. A brush of this type can be used for both fine, delicate strokes and broader strokes and flat washes. Apart from the standard length of brush head, rounds also come in short lengths ('spotter' brushes) and long lengths ('rigger' brushes).

SPOTTER BRUSHES

Retouching or spotter brushes have a fine point, and the very short head gives extra control. They are used mainly by miniaturists and botanical artists, for precise details.

RIGGER BRUSHES

A long-haired round brush is known as a designer's point, writer or rigger (from when the brush was used for painting the finely detailed rigging on sailing ships). The long shape gives an extra-fine point and good colour-holding properties, allowing fine lines and tapered strokes.

MOPS AND WASH BRUSHES

These are made from synthetic, goat or squirrel hair, and are used for laying in large areas of colour quickly. Wash brushes are generally wide and flat, while mops have large round heads.

Starter selection
For a good starter set, choose Nos 3, 5 and 12 round brushes.

Care of brushes
Brushes will last longer and be far more pleasant to work with if you follow a few simple rules.

While painting, do not leave brushes resting on their bristles in water for long periods, as this can ruin both the hairs and the handles.

Immediately after use, rinse brushes in cold running water, making sure that any paint near the ferrule is fully removed.

After cleaning, shake out the excess water and gently shape up the hairs between finger and thumb. A little starch solution or thinned gum solution stroked onto the bristles will help them retain their shape; it is easily rinsed out with water when the brush is used again.

Leave brushes to dry either flat or up-ended in a pot or jar. When storing brushes for any length of time, make sure they are perfectly dry before placing them in a box that has a tight-fitting lid — mildew may develop if wet brushes are stored in an airtight container.

Moths are partial to animal-hair bristles, so protect your brushes in the long term with mothballs or a sachet of camphor. Horse chestnuts also keep moths at bay.

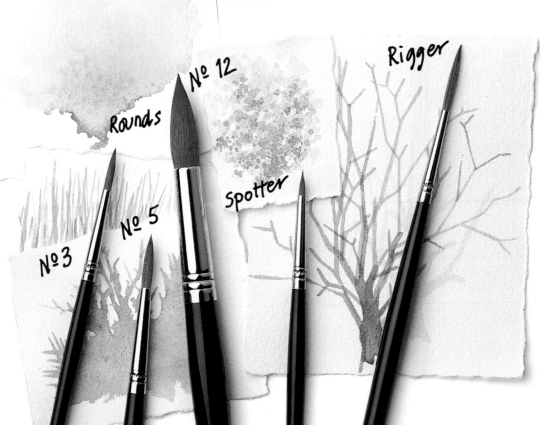

Rounds · No 3 · No 5 · No 12 · Spotter · Rigger

FLAT BRUSHES Flat watercolour brushes are also known as 'one-strokes'. These square-ended brushes, set into a flattened ferrule, are designed to give a high colour-carrying capacity and free flow of colour for laying in broad washes, while the chisel end creates firm, clean linear strokes. As with round brushes, a longer-haired flat is available, made from hard-wearing ox hair.

BRUSH SIZES All watercolour brushes are graded according to size, ranging from as small as 00000 to as large as a No. 24 wash brush. The size of a flat brush is generally given by the width of the brush, measured in millimetres or inches. Brush sizes are broadly similar between one manufacturer and another, but they do not appear to be standard – thus a No. 6 brush in one range will not necessarily be the same size as a No. 6 in another.

CHOOSING BRUSHES Experiment with all types and sizes of brush to discover their potential. Eventually, as you develop your individual approach to watercolour, you will settle on a few brushes which are suited to your own way of painting, and which you find comfortable to hold. To start with, a selection of three sable brushes – for instance, a No. 3, a No. 5 and a No. 12 round – should be sufficient.

As a rule, choose the largest suitable brush for any given application, as it is more versatile and holds more colour than a smaller version. A fairly large, good-quality brush, such as a No. 12, will cover large areas, yet come to a point fine enough to paint precise details.

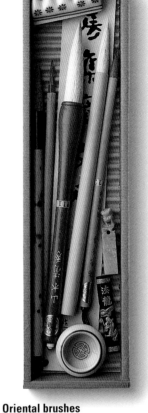

Oriental brushes
Oriental brushes, made from goat, wolf or hog hair set into hollow bamboo handles, are inexpensive and versatile. The thick, tapering head can make broad sweeps of colour, and can be drawn up to a very fine point for painting delicate lines. The heads are coated in starch size; remove this by soaking and teasing the hairs in a jar of water for a minute or two.

Orientals

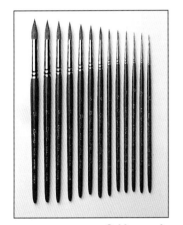

Sable rounds
The brushes shown here range from 000 up to 12; even smaller and larger brushes are available.

Flats

Mop brush

PALETTES

Watercolour palettes are available in a variety of shapes and sizes, but they all feature recesses or wells which allow you to add the required quantity of water to the paint, and prevent separate colours from running together.

CHOOSING A PALETTE Manufactured palettes are made of white ceramic, enamelled metal or plastic; ceramic is perhaps the most sympathetic surface for mixing colours. Plastic palettes are cheap and lightweight; although ideal for outdoor painting, they eventually become stained with paint residue because they are slightly absorbent. Which kind of palette you prefer is largely dependent on personal taste and the scale and style of your work. However, certain types are best suited to particular purposes.

INTEGRAL PALETTES Enamelled-metal painting boxes, designed to hold pans or tubes of paint, are particularly useful when working outdoors, as the inside of the lid doubles as a palette and mixing area when opened out. Some boxes also have an integral hinged flap for mixing and tinting, and a thumb ring in the base.

SLANTED-WELL TILES These are long ceramic palettes divided into several recesses or wells, allowing several colours to be laid out without them flowing into one another. The wells slant so that the paint collects at one end ready for use and can be drawn out for thinner washes. Some slanted-well tiles have a row of smaller and a row of larger wells; paint is squeezed into the small wells and moved to the larger wells, to be diluted with water or mixed with other colours.

TINTING SAUCERS These small round ceramic dishes are used for mixing larger quantities of paint. They are available divided into four recesses, for mixing separate colours, or undivided, for mixing a single colour.

PALETTE TRAYS When mixing large quantities of liquid paint, you will need a palette with deep wells. These palettes are usually made of plastic or more stain-resistant, high-impact polystyrene.

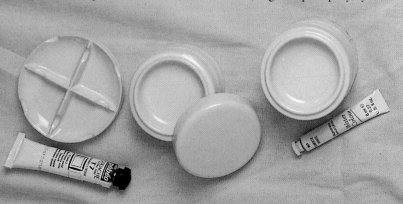

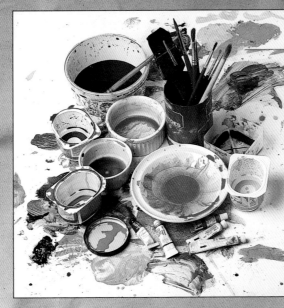

Improvised palettes

Improvised palettes are cheap and easy to obtain, and artists often prefer them because there is no restriction on size. You can use a variety of household containers, as long as they are white and non-porous. Depending on how large a mixing area you want, a white saucer, plate or enamelled pie plate can make a perfectly adequate palette. Hors d'oeuvres dishes are particularly useful, as they provide several large mixing areas. When mixing large quantities of wash, use old cups, bowls or yoghurt pots.

Palettes for watercolour

Shown here and on the opposite page are a selection of manufactured palettes suitable for watercolour painting.

Opposite, from left to right:
Quartered tinting saucer; round cabinet saucers (all ceramic).
Centre, from top to bottom:
Deep-well palette tray; large mixing palettes with thumb hole and divisions (all plastic).
Right, from top to bottom:
Enamelled-metal painting box with integral palette; ceramic slanted-well tile; segmented white china round palette.

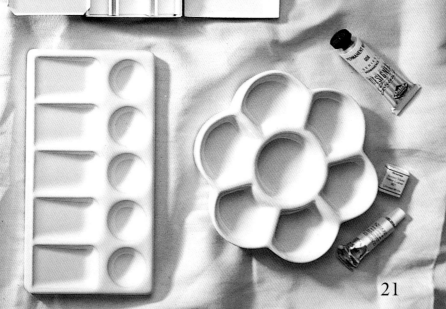

21

ACCESSORIES

Useful items, such as mediums, masking fluid, scraping tools and sponges, will broaden the range of techniques at your disposal.

WATER CONTAINERS

Do not skimp on water when painting in watercolour – use as large a container as you can find, otherwise the water quickly becomes murky as you rinse your brush between washes, and this may spoil the transparency of your colours. Some artists prefer to use two water containers, one to rinse brushes and the other to use as a dipper for mixing colours.

When painting outdoors, use a plastic water container, which is lighter and less liable to break than glass. You can buy collapsible plastic containers with a handle, or simply cut the top off a plastic bottle (see right). You may also have to transport water to your location, and a larger container to decant from will be useful.

MASKING FLUID

This is a quick-drying, liquid latex used to mask off selected areas of a painting when applying colour in broad washes. There are two types available: tinted and colourless. The tinted version is preferable, as it is more versatile and is easier to work with on white paper.

GUM ARABIC

A pale-coloured solution of gum arabic in water increases both the gloss and transparency of watercolour paints when mixed with them. Diluted further, it improves paint flow. Too much gum arabic will make paint slippery and jelly-like, but in moderation it enlivens the texture and enhances the vividness of the colours.

OX GALL

A straw-coloured liquid made from the gallbladders of cattle, which is added to water in jars to improve the flow and adhesion of watercolour paints, particularly for wet-in-wet techniques. It has been largely replaced by synthetic products.

GELATINE SIZE

This liquid, sold in small bottles, may be applied to the surface of a watercolour paper which is too absorbent. Apply with a large soft brush, and leave to dry for a few minutes. The size reduces the absorbency of paper, making it easier to apply washes.

GLYCERINE

You will find glycerine useful when working outdoors in dry conditions. A few drops added to water will counteract the drying effects of wind and hot sun by prolonging the time it takes for watercolour paint to dry naturally.

ALCOHOL

This has the opposite effect to glycerine, speeding the drying time of watercolour paint. It is very useful when working outdoors in damp weather conditions.

• Distilled water
Some watercolour painters prefer to use distilled water for mixing colours, as it contains no impurities.

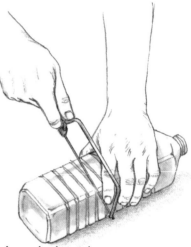

Improvised containers
Recycle plastic bottles into useful containers – some bottles have convenient guidelines for cutting. Cut them to the required height with a hacksaw or craft knife; the left-over neck can be used as a funnel.

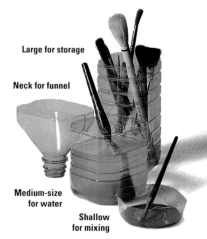

Large for storage

Neck for funnel

Medium-size for water

Shallow for mixing

SCRAPING AND COLOUR-LIFTING TOOLS
You can use a single-edged razor blade, scalpel, cocktail stick, the end of a paintbrush handle, even your thumbnail, for scraping out unwanted areas of still-wet watercolour or for scratching lines into dry paint to create textured effects. Fine sandpaper can be used to rub away some of the colour, creating a drybrush-like sparkle. Cotton buds can be employed for lifting out small areas of still-wet colour. Blotting paper is also useful for lifting out colour and for mopping up spills.

SPONGES
Natural and synthetic sponges are often used for dabbing on areas of rough-textured paint. They are also used for wetting paper in preparation for applying washes, and to lift out wet paint or mop up paint that has run too much. Natural sponges are more expensive than synthetic ones, but they have a pleasing silky texture and produce interesting random patterns.

Selection of accessories
Shown below is a typical assortment of materials used to create watercolour textures and expand techniques.

Top shelf, from left to right:
water container for mixing and wetting; gelatine; ox gall; masking fluid; cotton buds and cocktail sticks; natural and synthetic sponges.

Bottom shelf, from left to right:
clips for holding paper; gum arabic; glycerine; water container for washing brushes; alcohol; abrasive paper; craft knives and sharpened paintbrushes for lifting and scraping.

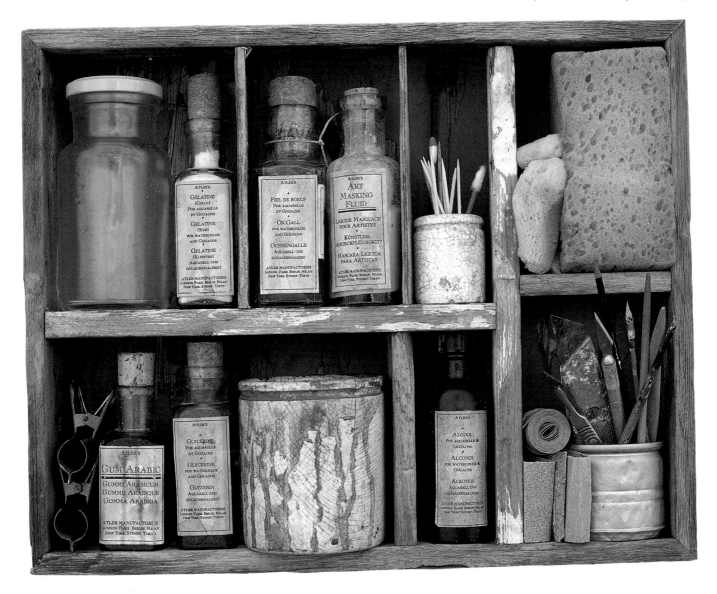

WASH TECHNIQUES

Washes are the very foundation of watercolour painting. One of the unique qualities of the medium is the way in which atmosphere and light can be conveyed by a few brushstrokes swept over sparkling white paper.

CHOOSING PAPER

Sized paper
The effect of painting washes on low-sized paper (below left) and hard-sized paper (bottom left).

Damp and dry paper
Washes laid on damp paper (below right) and dry paper (bottom right), both medium-sized.

The appearance of a wash depends on several factors: the type of pigment used and the level of dilution; the type of paper; and whether the surface is wet or dry when the wash is applied. For example, when washes are applied to an absorbent, low-sized paper, they dry with a soft, diffused quality. On hard-sized paper, wet washes spread more quickly and with less control, but this can create exciting effects. When a wash is laid on dampened paper, the paint goes on very evenly, because the first application of water enables the pigment to spread out on the paper and dissolve without leaving a hard edge. Working on dry paper gives a much sharper, crisper effect, and some painters find it a more controllable method.

Laying washes
The following tips will help make successful washes.

Mix more colour than you think will be needed to cover an area – you cannot stop in the middle of laying a wash to mix a fresh supply.

A watercolour wash dries much lighter than it looks when wet, so allow for this when mixing paint.

Tilting the board at a slight angle allows a wash to flow smoothly downward without dripping.

Use a large round or flat brush. The fewer and broader the strokes, the less risk of streaks developing.

Keep the brush well loaded, but not overloaded. Streaking is caused when a brush is too dry, but if your brush is overloaded, washes can run out of control.

Don't press too hard. Sweep the brush lightly, quickly and decisively across the paper, using the tip, not the heel.

Never work back into a previously laid wash to smooth it out – it will only make matters worse.

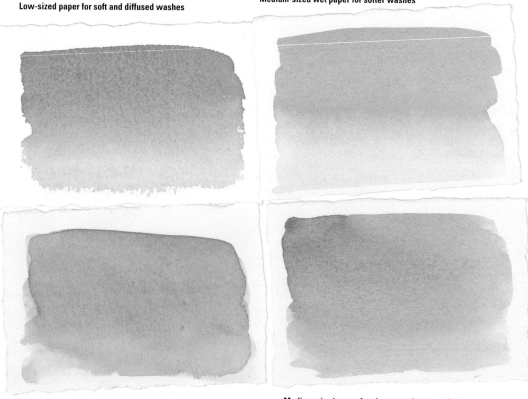

Low-sized paper for soft and diffused washes

Medium-sized wet paper for softer washes

Hard-sized paper for quick-spreading washes

Medium-sized paper for sharper, crisper washes

ACHIEVING SMOOTH WASHES

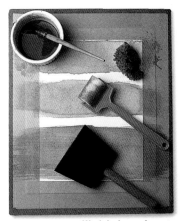

Wash-laying equipment

Laying a large, overall wash free of streaks or runs requires practice. Where heavy washes are to be applied, the paper must be stretched and taped firmly to a board, to prevent cockling or wrinkling. Opinions vary as to whether large areas of wash should be laid on dry or damp paper. Some artists find that a uniform tone is easier to achieve on dry paper, while others find that the paint streaks. Some feel that washes flow more easily on damp paper, and still others find that slight cockling, even of stretched paper, can produce streaks and marks as the paint collects in the 'dips'. Results vary, too, according to the type of paper used; the only answer is to experiment for yourself.

Wash-laying equipment
As well as natural sponges, synthetic-sponge rollers and sponge brushes (left) can be used to lay a smooth wash. For a dense, thick covering, make sure the sponge is filled with plenty of paint. For paler tones or variegated effects, squeeze out some of the paint.

Robert Tilling
ROCKS, LOW TIDE
Watercolour on paper
50 x 65cm (20 x 26in)

Tilling uses the wet-in-wet method to explore the interactions of sky, sea and land. He mixes large quantities of paint in old teacups and applies it with large brushes, tilting his board at an acute angle so that the colours flow down the paper, then reversing the angle to control the flow. When the paper has dried, he paints the dark shapes of rocks and headland wet-on-dry for more crisp definition.

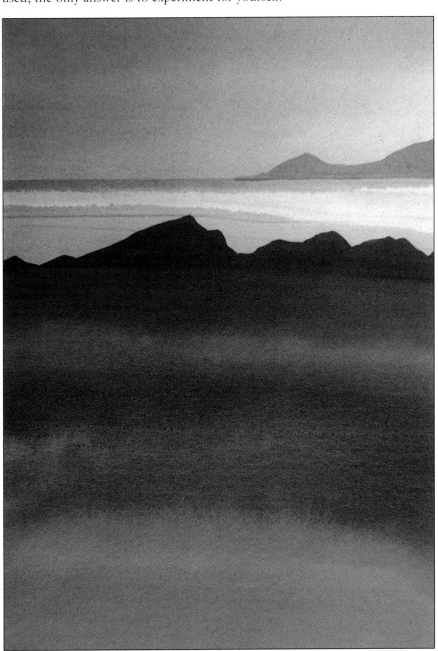

FLAT & GRADED WASHES

There are two basic types of wash: a flat wash is evenly toned and is often used to cover the whole area of the paper with a unifying background colour. A graded wash moves gradually from light to dark, from dark to light, or from one colour to another. Graded washes are most often used in painting skies, where the colour fades gradually towards the horizon.

FLAT WASHES

Watercolourists normally employ flat washes as integral parts of a painting, frequently overlaying one wash with another. However, a flat wash is also used merely to tint white paper as a background for body colour or gouache.

Laying a basic wash
Here the flat-wash method is used to create an overall sky effect using diluted indigo blue.

1 Mix up plenty of colour in a saucer or jar. Place the board at a slight angle, then dampen the paper surface with water, using a mop brush or a sponge.

2 Load the brush with paint and draw a single, steady stroke across the top of the area. Due to the angle of the board, a narrow bead of paint will form along the bottom edge of the brushstroke; this will be incorporated into the next stroke.

3 Paint a second stroke beneath the first, slightly overlapping it and picking up the bead of paint. Continue down the paper with overlapping strokes, each time picking up the excess paint from the previous stroke. Keep the brush well loaded with paint.

4 Use a moist, clean brush to even up the paint that gathers along the base of the wash. Leave to dry in the same tilted position, otherwise the paint will flow back and dry, leaving an ugly tidemark.

1 Dampen the paper surface with a sponge.

2 Draw a single stroke across the top.

3 Paint a second stroke beneath the first.

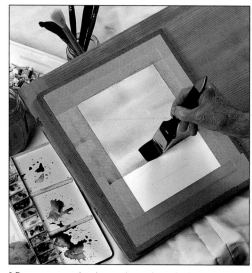

4 Even up any paint that gathers along the base.

GRADED WASHES The method of applying a graded wash is the same as for a flat wash, except that with each successive brushstroke the brush carries more water and less pigment (or vice versa if you are working from light to dark).

It takes a little practice to achieve a smooth transition in tone, with no sudden jumps. The secret is to apply a sufficient weight of paint so that the excess flows very gently down the surface of the paper, to be merged with the next brushstroke.

Wash-laying technique
Here the graded-wash technique is used to create another sky scene. Cobalt blue is diluted with water in each subsequent brushstroke.

1 Dampen the paper as for laying a flat wash, and lay a line of colour at full strength across the top of the area to be painted. Allow the colour to spread and even out.

2 Quickly add a little more water to the paint on your palette and lay a second band of colour, slightly overlapping the first.

3 Continue down the paper, adding more water to the paint with each succeeding stroke and ending with a stroke of pure water. As with flat washes, the brush used to mop up paint along the base of the wash must be clean and moist. Leave to dry in the same tilted position as for flat washes.

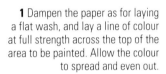

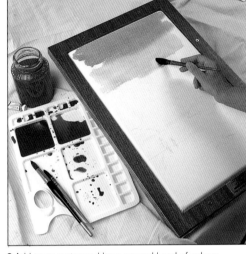

1 Lay a line of colour at full strength across the top.

2 Add more water and lay a second band of colour.

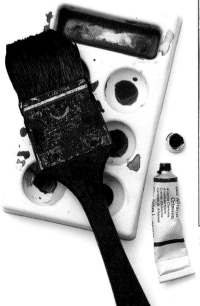

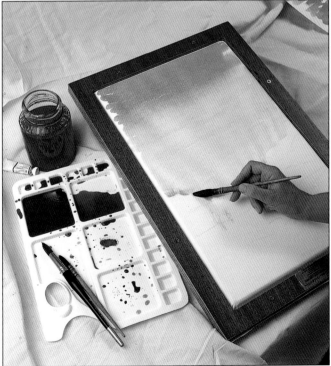

3 Continue down the paper adding water to the paint with each stroke.

Variegated washes
The technique shown below enables you to lay two or more colours in a wash.

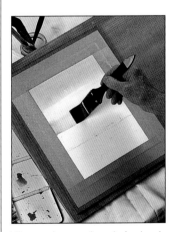

Mix your chosen colours beforehand, and then apply the first line of colour along the top of the paper. Always washing the brush between colours, apply another colour, partly on blank paper and partly touching the first. Repeat this with any other colours.

Sophie Knight
STILL-LIFE REFLECTIONS
Watercolour and acrylic on paper
35 x 55cm (14 x 22in)

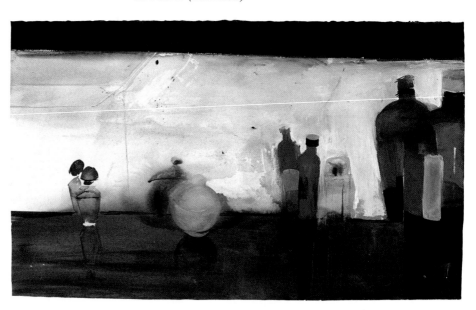

John Blockley
SHOP FLOWERS
Watercolour on paper
43.2 x 43.2cm (17 x 17in)

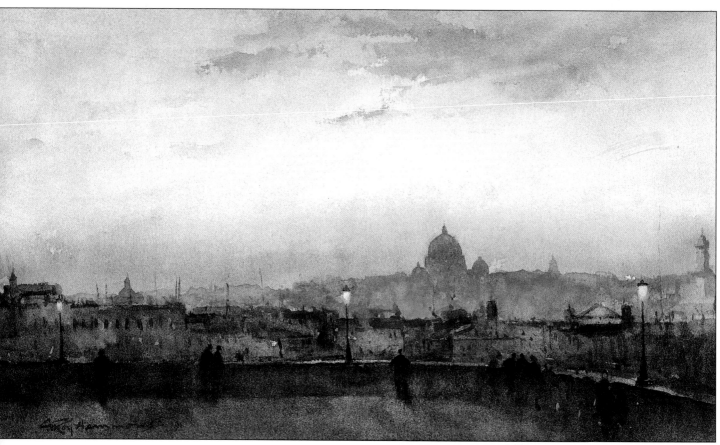

Roy Hammond
LONDON SUNSET
Watercolour on paper
16.2 x 23.7cm (6½ x 9½in)
Chris Beetles Gallery, London

28

Different approaches

Experiment with watercolour and get to know its characteristics. With experience, you will develop a painting style as unique and individual to you as your handwriting style.

It is interesting to compare the two very different approaches to a similar theme adopted by Penny Anstice and Ron Jesty. Working on damp paper, Anstice applies wet pools of colour and allows them to flood together, relishing the element of chance that makes wet-in-wet such an exciting technique.

In contrast, Jesty uses a careful and methodical approach, building up form and tone with superimposed washes applied wet-on-dry. He leaves the painting to dry between stages so that the colours aren't muddied but remain crisp and clear.

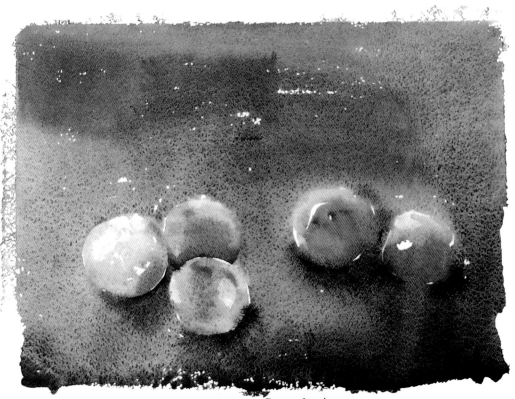

Penny Anstice
NECTARINES
Watercolour on paper
30 x 45cm (12 x 18in)

Variety and contrast (opposite)

A flower painting, a table-top still life and a landscape demonstrate some of the variety of technique and contrast of style which can be achieved with watercolour.

The flower painting (above left) belies watercolour's reputation for being a medium for little old ladies. Blockley attacks his subjects with gusto – here using broad household paintbrushes to apply vertical streaks of colour in the foreground.

Watercolour is combined with acrylic paint (above right) to give it body while retaining its translucence. Most of the paint is applied wet-in-wet, so that the shapes and colours are suggested rather than literally described.

The evening sky (left) has been beautifully described by means of graded washes of pale, pearly colour. The dark tones of the buildings, painted with overlaid washes, accentuate the luminosity of the sky.

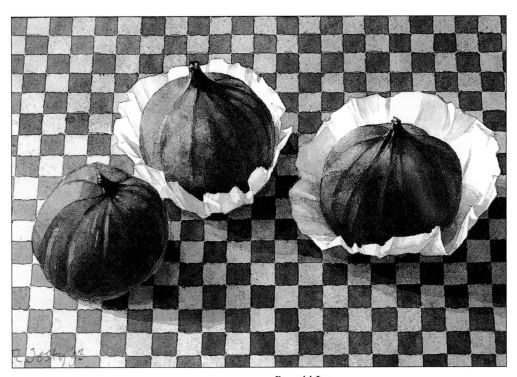

Ronald Jesty
THREE FIGS
Watercolour on paper
15 x 20.6cm (6 x 8¼in)

WET-IN-WET

Wet-in-wet is one of the most expressive and beautiful techniques in watercolour painting. When colours are applied to either a damp sheet of paper or an area of still-wet paint, they run out over the wet surface, giving a soft, hazy edge to the painted shape. This technique is particularly effective in painting skies and water, producing gentle gradations of tone which evoke the ever-changing quality of light.

CHOOSING PAPER

It is vital to choose the right type of paper for wet-in-wet. Avoid papers which are too smooth or which are heavily sized, as the paint tends to sit on the surface. A gently absorbent Not (cold-pressed) surface is ideal, allowing washes to fuse into the paper structure. The paper should also be robust enough to bear up to frequent applications of water without cockling. Lighter papers must be stretched and taped to the board. With heavier-grade papers of 410gsm (200lb) or over, you may get away without stretching, but where heavy applications of wash are to be used, it is best to err on the side of caution.

Tilting the board
The board should be tilted at an angle of roughly 30 degrees so that the colours can flow gently down the paper. If the board is laid flat, washes cannot spread and diffuse easily, and there is a danger of colours creeping back into previously laid colours, creating unwanted marks and blotches.

CONTROLLING WET-IN-WET

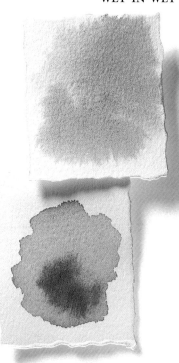

Although wet-in-wet painting produces spontaneous effects, it takes practice and experience to be able to judge how wet the paper and the strength of the washes need to be, in order to control the spread and flow of the paint.

Use a soft sponge or large brush to dampen the paper with clean water. The surface should be evenly damp overall; use a tissue to blot up any pools of water, then take your courage in both hands – and your brush in one – and apply the colours. Work quickly and confidently, allowing the colours to diffuse and go where they will. Some degree of control can be gained by tilting the board in any direction, but only slightly – this is where the interest and creative tension come in. If a wash runs out of control or goes where it shouldn't, lift out some of the colour with a soft, dry brush, or gently blot it with a tissue.

Dilution and colour

Make sure not to over-dilute paint, as this can make the finished picture appear pale and wan. Because you have wetted the paper, it is possible to use rich paint – but not so thick that it doesn't spread. The paint will keep its rich hue as it softens on the damp paper. The colour will appear darker when wet and will dry to a lighter shade, particularly where an absorbent paper is used, so make allowances for this when applying paint.

Wet-in-wet effects
Paint applied directly onto wet paper (left, top). Paint applied into wet paint (left, bottom). Controlled single-colour paint run on wet paper (above).

Wet-on-dry

In this classic technique, tones and colours are applied in a series of pure, transparent layers, one over the other, each wash being allowed to dry before the next is added.

SUPERIMPOSED COLOUR

The dry surface of the paper 'holds' the paint, so that brushstrokes will not distort or run out of control. Light travels through each transparent wash to the white paper beneath, and reflects back through the colours. Superimposed washes of thin, pale colour result in more resonant areas of colour than can be achieved by a single, flat wash of dense colour.

CHOOSING PAPER

The most suitable paper for this technique is one which is surface-sized, presenting a smooth, hard surface that holds the paint well. Working wet-on-dry requires a little patience, as each layer must dry before the next is applied; otherwise the colours will mix and become muddied, and crispness and definition are lost. To speed up the process, you can use a hair dryer on a cool-to-warm setting – let the wash sink in a little first, otherwise it will get blown around on the paper and lose its shape.

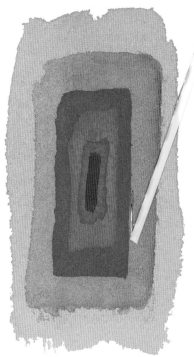

Patrick Procktor
PORTRAIT OF EMIL ASANO
Watercolour on paper
63.5 x 47cm (25½ x 18¾in)
Redfern Gallery, London

The success of this painting relies on the simplicity of the design and the controlled, almost restrained, use of two basic watercolour techniques. A series of flat washes indicates the walls and furnishings, capturing the oriental simplicity of the interior. The pattern of the blouse employs the wet-in-wet technique, successfully conveying the softness and fluid colour of the model's costume, which is also reflected in the table top. Note, too, the softness of the hairline against the background, again achieved by working wet-in-wet.

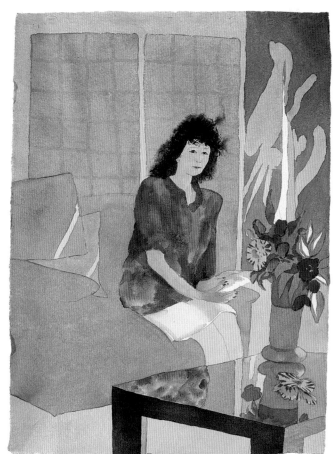

Keeping colours fresh
If you apply too many layers of paint, the attractive delicacy and freshness of the medium may be lost. It is best to apply a few layers confidently rather than risk muddying the painting by continually adding more, so it is advisable always to test colours by layering them on scrap paper (above) before committing them to the surface. Another common cause of muddy colours is dirty water, so always rinse your brush thoroughly between colours and ensure that you regularly refill your water jar with clean water.

CREATING HIGHLIGHTS

Many inexperienced watercolourists make the mistake of trying to cover every part of the paper with paint: in fact, with watercolour this is neither necessary nor desirable. The light-reflecting surface of watercolour paper provides a uniquely brilliant white which can be used to great effect, adding sparkle to your colours and allowing the painting to 'breathe'. Described below are some of the techniques used to manipulate the paint to create white highlights in a watercolour wash.

Creating a soft edge
Use damp paper or blend into the white area with a soft, damp brush.

RESERVING WHITE AREAS

The simplest way to create white highlights in a watercolour painting is to paint around them, thereby preserving the white of the paper, with its brilliant light-reflecting properties. Reserving highlights in this way requires careful planning, because it is not always possible to retrieve the pristine white of the paper once a colour has been inadvertently applied.

When you paint around an area to be reserved for a highlight, the paint will dry with a crisp hard edge. For a softer edge, work on damp paper or blend coloured edges into the white area with a soft, damp brush while the paint is still wet.

Lifting out wet paint
Use a soft brush, a sponge or a tissue for soft highlights.

LIFTING OUT

Another method of creating highlights is by gently removing colour from paper while it is still wet, using a soft brush, a sponge or a tissue. This lifting-out technique is often used to create soft diffused highlights, such as the white tops of cumulus clouds. It can also be used to soften edges and to reveal one colour beneath another.

Paint can be lifted out when dry by gentle coaxing with a damp sponge, brush or a cotton bud. Results will vary according to the colour to be lifted (strong stainers such as alizarin crimson and phthalocyanine green may leave a faint residue) and the type of paper used (paint is more difficult to remove from soft-sized papers). In some cases, pigment may be loosened more easily using hot water, which partially dissolves the gelatine size used on the surface of the paper.

Lifting out dry paint
Use a damp sponge, brush or a cotton bud.

USING BODY COLOUR

Some of the greatest watercolourists, from Dürer to Turner to Sargent, used touches of body colour for the highlights in their paintings, with breathtaking results. As long as opaque parts of the painting are as sensitively and thoughtfully handled as transparent areas, they will integrate naturally into the whole scheme.

Using body colour
Small amounts of body colour can provide the finishing touches.

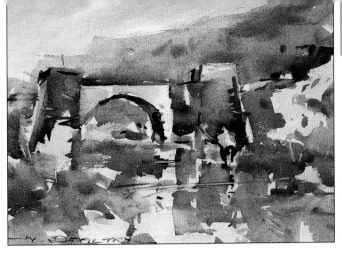

In this fresh painting, broad washes have been rapidly manipulated with a flat brush, simplifying the scene almost to abstraction, yet keeping its essential character. The unpainted areas give an impression of movement and changing light.

William Dealtry
NORTH YORKSHIRE STREAM
Watercolour on paper
16.2 x 22.5cm (6½ x 9in)
Brian Sinfield Gallery, Burford

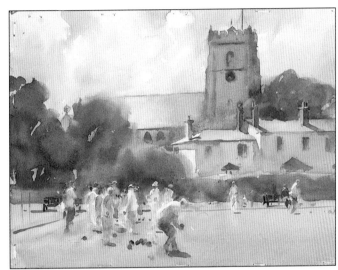

A quintessential country scene, Chamberlain's painting exudes an air of calm and tranquillity. The effect of sunlight glancing off the players' white shirts is skilfully wrought by means of a little judicious lifting out of colour to create suffused highlights.

Trevor Chamberlain
BOWLS MATCH, SIDMOUTH
Watercolour on paper
22.5 x 30cm (9 x 12in)

Hercules B. Brabazon
(1821-1906)
CADIZ, 1874
Watercolour and body colour
on tinted paper
26.2 x 35cm (10½ x 14in)
Chris Beetles Gallery, London

Although he did not receive public recognition until the age of 71, Brabazon's bravura technique and boldly conceived compositions placed him among the most progressive artists of his day. This painting is typical of his ability to pare down to the essentials of his subject. It is painted with transparent colour on tinted paper, with rich, creamy accents provided by white body colour overlaid with watercolour.

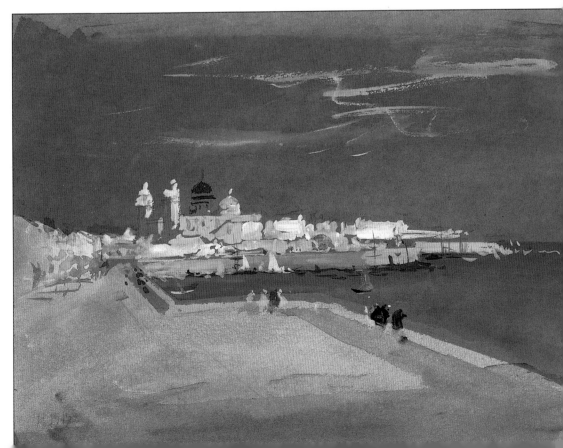

MASKING OUT

Because of the transparent nature of watercolours, light colours and tones cannot be painted over dark ones, as they can in oils or acrylics. Light or white areas must be planned initially and painted around. This is not difficult for broad areas and simple shapes, but preserving small shapes, such as highlights on water, can be a nuisance, as the method inhibits the flow of the wash.

One solution is to seal off these areas first with masking fluid, thus freeing yourself from the worry of accidentally painting over areas you wish to keep white.

Using masking fluid

Masking fluid is a liquid, rubbery solution which is applied to paper with a brush. It dries quickly to form a water-resistant film which protects the paper underneath it. When both the masking fluid and the surrounding paint are dry, the fluid can be removed by rubbing with a clean fingertip or with an eraser.

Masking fluid can also be used in the later stages of a painting, to preserve areas of any specific tone or colour in a surrounding wash (make sure the area to be preserved is completely dry before applying the fluid).

Ideally, masking fluid should be removed from a painting within 24 hours of application, otherwise it will be difficult to rub off and may leave a slight residue.

If you intend to use masking fluid, choose a paper with a Not (cold-pressed) surface, from which it is easily removed; it is not suitable for rough papers, as it sinks into indents and cannot be peeled off completely.

Highlights created with glasspaper

SCRATCHING OUT

Fine linear highlights, such as light catching blades of grass, can be scratched out of a painted surface when it is dry, using a sharp, pointed tool, for instance a scalpel or craft knife, or even a razor blade. Avoid digging the blade into the paper, and work gently by degrees.

DIFFUSED HIGHLIGHTS

A more diffused highlight, such as the pattern of frothy water on ocean waves or waterfalls, can be made by scraping the surface gently with the side of the blade or with a piece of fine glasspaper. This removes colour from the raised tooth of the paper only, leaving colour in the indents and creating a mottled, broken-colour effect.

More delicate, muted highlights can be scratched out of paint that is not quite dry, using the tip of a paintbrush handle, or even your fingernail – Turner is said to have grown one fingernail long, especially for scratching out highlights from his watercolours.

Scratched highlights and marks
The examples above show four ways to create highlights: (from top to bottom) scratching with a blade point; scratching with a blade edge; scraping with a blunt paintbrush handle; scraping with a sharpened paintbrush handle.

Blades, abrasive papers and sharpened brush handles make useful highlighting tools

Cleaning brushes

Masking fluid is tough on brushes – even with careful cleaning, dried fluid can build up on brush hairs over a period of time. Always use cheap synthetic brushes to apply fluid – not your best sable! The best method of cleaning synthetic brushes is to rinse them in lighter fuel and leave them to dry.

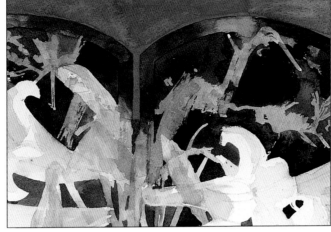

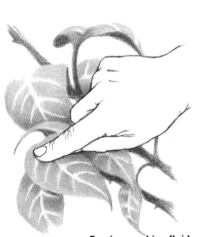

• Using masking fluid

Before using, shake the bottle to ensure the correct consistency. Too-thin fluid will not resist paint. Once opened, a bottle of masking fluid has a shelf life of around one year. After this, it will not work well. Excessive heat can make masking fluid unworkable. When painting in hot climates, store masking fluid somewhere cool, and work in the shade when applying it to paper.

Shirley Trevena
WHITE LILIES ON A
PATTERNED SCREEN
Watercolour and
gouache on paper
45.5 x 35.5cm (18¼ x 14¼in)

On the oriental screen (see detail above), the patterns were painted with masking fluid before the dark washes were applied. The mask was then removed and the mother-of-pearl colours painted in.

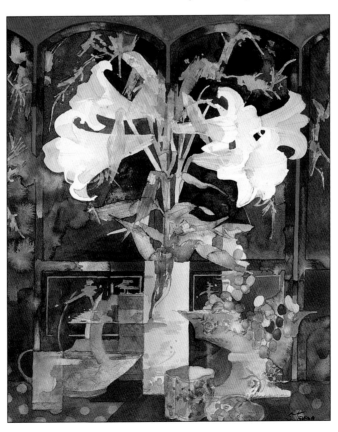

Erasing masking fluid

Use a pencil eraser or a fingertip.

Masking-fluid effects

Masking fluid is an invaluable accessory to watercolour painting. Use it where you want light areas or highlights to appear in your picture. Apply paint over the masking fluid and then remove it (see left) to reveal the white of the paper or the previously laid colour (above).

TEXTURES & EFFECTS

One of the attractions of watercolour is its freshness and immediacy – its power to suggest without overstatement. The experienced artist knows that, very often, magical things happen quite unexpectedly when water and pigment interact on paper; the paint actually does the work for you, producing atmospheric effects or patterns that resemble natural textures. A 'bloom' appears in a wash, resembling a storm cloud; a wash dries with a slightly grainy quality that adds interest to a foreground; or a swiftly executed brushstroke catches on the ridges of the paper and leaves a broken, speckled mark suggestive of light on water.

Pigment granulation
Some pigments show a tendency to granulate or flocculate, producing subtly textured washes, while others produce flat, even washes. An understanding of how different pigments behave will open up exciting possibilities for creating particular effects.

'IN MY CASE, <u>ALL</u> PAINTING IS AN ACCIDENT. . . . IT TRANSFORMS ITSELF BY THE ACTUAL PAINT. I DON'T, IN FACT, KNOW VERY OFTEN WHAT THE PAINT WILL DO, AND IT DOES MANY THINGS WHICH ARE VERY MUCH BETTER THAN I COULD MAKE IT DO. PERHAPS ONE COULD SAY IT'S NOT AN ACCIDENT, BECAUSE IT BECOMES PART OF THE PROCESS WHICH PART OF THE ACCIDENT ONE CHOOSES TO PRESERVE.'

FRANCIS BACON (1909-92)

SUBTLETY AND RESTRAINT

Because these effects occur naturally, they do the job without appearing laboured. Of course, it is possible for the artist to take an interventionist approach and deliberately manipulate the paint or even add things to it, in order to imitate certain textures and surface effects. Some of these techniques are described below, but it is important to realize that, if overdone, texturing techniques can easily appear facile. Use them with subtlety and restraint, so that they are incorporated naturally within the painting as a whole.

GRANULATION

This is a phenomenon which often occurs seemingly by accident, yet can impart a beautiful, subtle texture to a wash. Certain watercolour pigments show a tendency to precipitate: the pigment particles of the earth colours, for example, are fairly coarse. As the wash dries, tiny granules of pigment float in the water and settle in the hollows of paper, producing a mottled effect. Only experience and testing will tell you how much granulation may take place. Some colours granulate only when they are laid over a previous wash; and granulation may not happen at all, or may be hardly noticeable, if paint is heavily diluted.

FLOCCULATION

A similar grainy effect is produced by pigments, such as French ultramarine, which flocculate: the pigment particles are attracted to each other rather than dispersing evenly. This causes a slight speckling which lends a wonderful atmospheric quality to skies and landscapes in particular.

Simply by experimenting with paints, and knowing which colours have this settling tendency, it is possible to suggest textures such as weatherbeaten rocks, newly fallen snow, or sand, quite effortlessly.

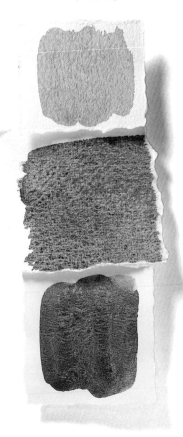

Experiment with various colours and makes to find out which pigments tend to granulate or flocculate

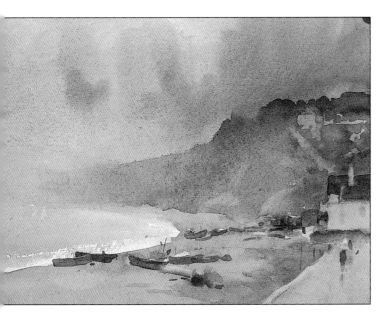

Trevor Chamberlain
RAIN AT BUDLEIGH SALTERTON
Watercolour on paper
17.5 x 25cm (7 x 10in)

Granulation of pigments
Certain watercolour pigments separate out, giving a granular effect which can be subtly descriptive and expressive.

In each of the three paintings on this page, the artists have made quite deliberate use of granulation. It enlivens the background wash in Patrick Procktor's portrait, while Trevor Chamberlain and Robert Tilling have used it to suggest subtle, atmospheric effects in the sky and landscape.

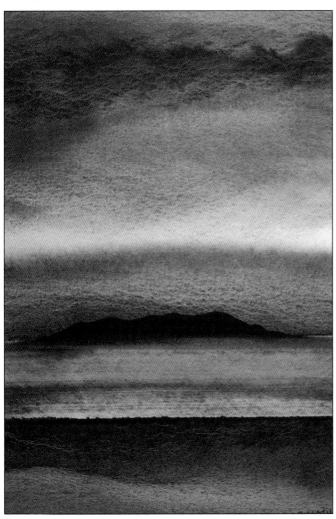

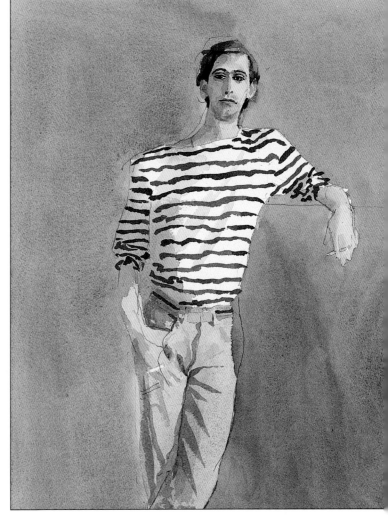

Robert Tilling
EVENING LIGHT
Watercolour on paper
65 x 50cm (26 x 20in)

Patrick Procktor
VASCO
Watercolour on paper
50.8 x 35.5cm (20⅜ x 14¼in)
Redfern Gallery, London

BLOOMS

Blooms, or backruns, sometimes occur when a wet wash is flooded into another, drier wash; as the second wash spreads, it dislodges some of the pigment particles beneath. These particles collect at the edge of the wash as it dries, creating a pale, flower-like shape with a dark, crinkled edge.

Although blooms are usually accidental – and often unwanted – they can be used to create textures and effects that are difficult to obtain using normal painting methods. For example, a series of small blooms creates a mottled pattern suggestive of weathered, lichen-covered stone; in landscapes, blooms can represent amorphous shapes such as distant hills, trees and clouds, or ripples on the surface of a stream; and they add texture and definition to the forms of leaves and flowers.

Creating blooms
It takes a little practice to create deliberate blooms. Apply the first wash and allow it to dry a little. When the second wash is applied, the first should be damp rather than wet; if it is too wet, the washes will merge together without a bloom.

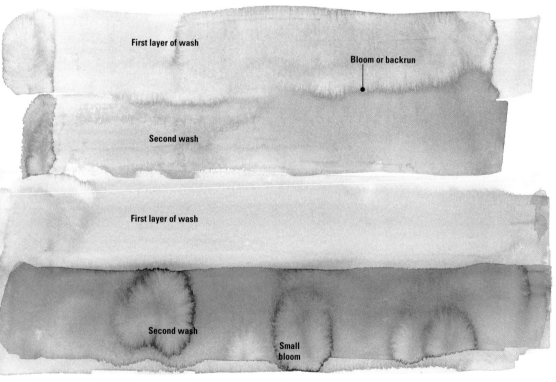

First layer of wash

Bloom or backrun

Second wash

First layer of wash

Second wash

Small bloom

Making small blooms
Small, circular blooms are formed by dropping paint from the end of a brush into a damp wash. You can also create pale blooms in a darker wash by dropping clear water into it.

DRYBRUSH

The drybrush technique is invaluable in watercolour painting, because it can suggest complex textures and details by an economy of means. Drybrush is used most often in landscape painting, to suggest natural effects such as sunlight on water, the texture of rocks and tree bark, or the movement of clouds and trees.

Moisten your brush with a very little water, and then take up a small amount of paint on the tip. Remove any excess moisture by flicking the brush across a paper tissue or a dry rag before lightly and quickly skimming the brush over dry paper.

• Drybrush technique
This is most effective on rough-textured paper, where the pigment catches on the raised tooth of the paper and misses the hollows, leaving tiny dots of white which cause the wash to sparkle with light.

John Lidzey
INTERIOR WITH HAT
Watercolour on paper
45 x 30cm (18 x 12in)

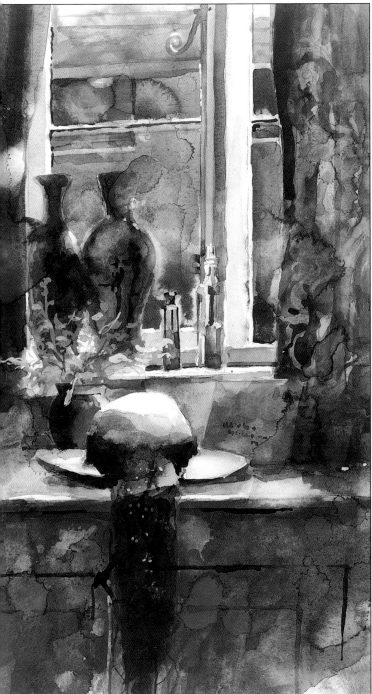

Unpredictable effects
The experienced watercolourist has experimented, and knows how to exploit the element of 'happy accident' in the paint.

The mercurial, unpredictable nature of watercolour is one of its chief joys. In the still-life paintings on this page, both artists have used the descriptive potential of backruns to suggest textures and enrich the picture surface.

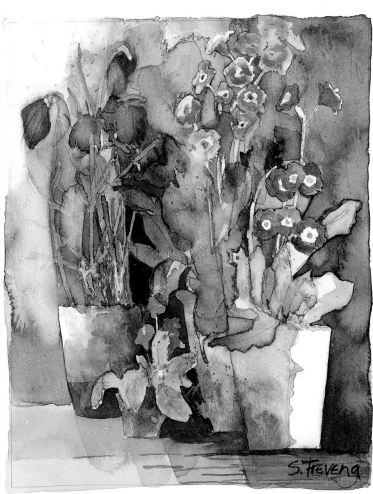

Shirley Trevena
FOUR FLOWERPOTS
Watercolour on paper
27.5 x 21.5cm (11 x 8⅝in)

39

Hans Schwarz
GLAZZ CAMPBELL,
AFTER TRAINING
Watercolour on paper
80 x 55cm (32 x 22in)

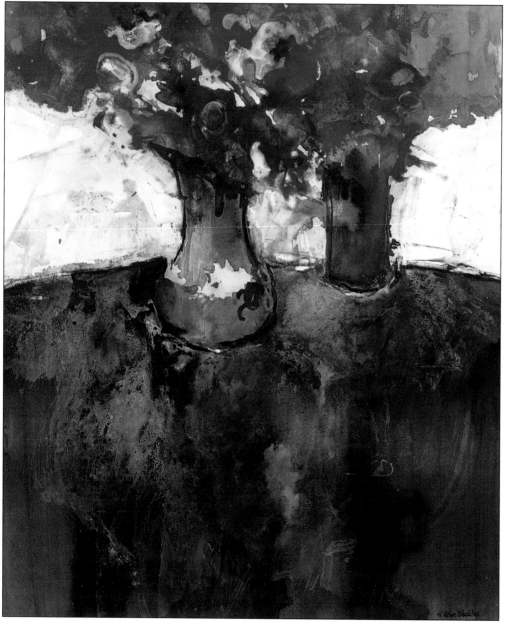

Brushmarks and effects
Brushmarks and effects play a vital and expressive part in watercolour painting.

Hans Schwarz has used a bold and direct approach, the brushmarks following and sculpting the forms of the face and figure to produce a lively, energetic portrait.

John Blockley's painting method involves a continual and daring process. He makes some areas wetter than others, then dries only some parts with a hair dryer. He then plunges the painting into a bath of water; the dry paint remains intact, but the wet paint floats off, leaving areas of white paper lightly stained with colour.

John Blockley
TABLE FLOWERS
Watercolour on paper
47 x 38cm (18½ x 15in)

USING SALT

Unpredictable effects can be obtained by scattering grains of coarse rock salt into wet paint. The salt crystals soak up the paint around them; when the picture is dry and the salt is brushed off, a pattern of pale, crystalline shapes is revealed. These delicate shapes are effective in producing the illusion of falling snow in a winter landscape, or for adding a hint of texture to stone walls and rock forms.

Although it may seem an easy technique, timing the application of salt requires practice. The wash should ideally be somewhere between wet and damp, neither too wet nor too dry. Applying salt to a wet wash will create large, soft shapes; applying it to a barely damp wash will produce smaller, more granulated shapes. Apply the salt sparingly to a horizontal surface, let it dry, and then brush the salt off.

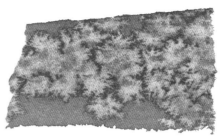

Using salt
As salt crystals soak up paint, a pattern of shapes emerges.

USING A SPONGE

Painting with a sponge creates textures and effects which are often impossible to render with a brush. For example, a mottled pattern suggesting clumps of foliage or the surface of weathered stone may be produced by dabbing with a sponge dipped in paint. Use a natural sponge, which is softer and more absorbent than a synthetic sponge, and has an irregular, more interesting texture.

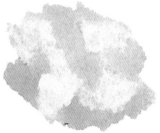

Using a sponge
Apply paint lightly with a natural sponge for textural effects.

WAX RESIST

A broken texture can be created by rubbing or drawing with a white wax candle or a coloured wax crayon and then overpainting with watercolour. Wax adheres unevenly to paper, catching on the raised tooth and leaving the hollows untouched. When a wash of colour is applied, the wax repels the paint, causing it to coagulate in droplets. The broken, batik-like effect created by wax resist can be used to suggest textures and surface effects, such as rocks, tree bark, sand, or light on water or grass.

This technique works best on a Not or rough surface. Skim a candle or wax crayon across the paper so that it touches the high points but not the indents, then apply your watercolours in the normal way. When the painting is completely dry, the wax can be removed by covering it with absorbent paper and pressing with a cool iron until the paper has absorbed all the melted wax.

Using a candle
Paint over rubbed- or drawn-on wax to create natural-looking textures.

USING TURPENTINE

In a variation on the resist technique, turpentine or white spirit can be sparingly applied to well-sized paper, allowed to dry slightly and then painted over. The paint and the oil will separate, creating an interesting marbled effect.

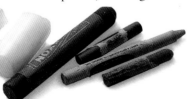

Turpentine, salt and wax can be used to create unpredictable textures

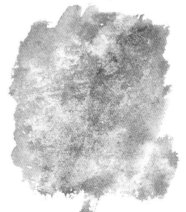

Using turpentine
Another version of the resist method involves applying turpentine.

GOUACHE

The term 'gouache' originates from the Renaissance, when the Italian masters painted 'a gouazzo' – with water-based distemper or size paints. The opacity of gouache and its matt, chalky appearance when dry, make it a quite separate and distinct medium from pure, transparent watercolour, but the equipment, supports and techniques used are similar for both media.

PAINTS

Availability of gouache
Standard-size tubes are convenient when painting outdoors, but pots of gouache are more economical for large-scale paintings.

The best-quality gouache paints contain a very high proportion of pigment; its density creates an opaque effect. The colours are therefore pure and intense, and create clean colour mixes. Because the natural covering power of each pigment is not increased artificially, it varies according to the pigment. The less-expensive gouache ranges contain an inert white pigment, such as chalk or blanc fixe, to impart smoothness and opacity.

Testing gouache
In terms of permanence, covering power and flow, gouache colours vary considerably from one manufacturer to another, and it is advisable to try out samples from different ranges in order to determine which are best suited to your own method of working.

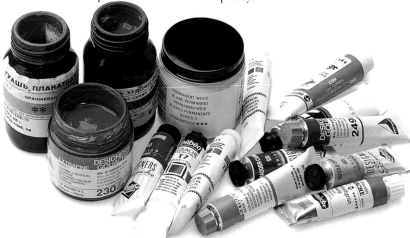

CHOOSING PAINT

Gouache paints are sold in tubes, pots and bottles, often labelled 'designers' colour'. This refers to the medium's popularity with graphic designers, who require bright colours with a matt finish. A vast range of colours is available, but this includes some brilliant colours which are fugitive; while this does not matter to designers, whose work is of a temporary nature, these fugitive colours are not recommended for fine permanent painting.

COLOUR MIGRATION

Certain dye-based gouache colours – lakes, magentas and violets – have a tendency to 'migrate', or bleed through when overpainted with light colours. One solution is to apply bleed-proof white between layers, to halt any further migration. This is a very dense designers' colour that may be classed as gouache.

Preventing colour migration
Colours may be mixed with acrylic glaze medium, which converts gouache into paint with an acrylic finish that is flexible and water-resistant. It allows washes to be superimposed without disturbing those below.

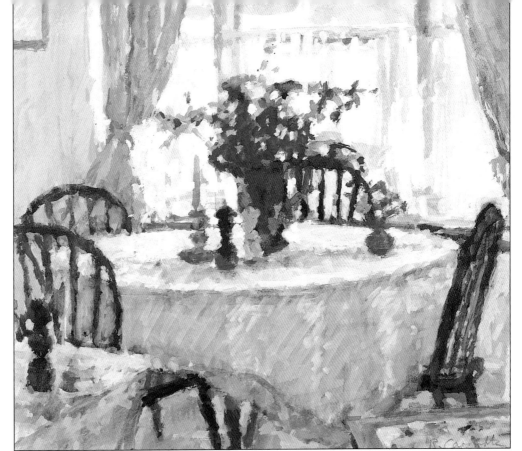

Rosemary Carruthers
WINDOW TABLE
(THE MOORINGS)
Gouache on paper
21.2 x 23.7cm (8½ x 9½in)
Llewellyn Alexander Gallery, London

Penny Quested
STILL LIFE WITH FLOWERS
Gouache on Japanese paper
67.5 x 57.5cm (27 x 23in)

The versatility of gouache

Depending on your temperament as an artist, you can choose either to exploit the brilliance and opacity of gouache or to create soft, subtle effects.

Although gouache is used in much the same way as watercolour, the feel of a gouache painting is more solid and robust. This quality is exploited to the full in the still life (left), in which the exuberance of the flowers is matched by the artist's joyous, uninhibited use of colour.

In contrast, the interior study (above) evokes a quiet, reflective mood. Here, the artist has used overlaid washes of semi-opaque colour, softened with white. The matt, airy quality of the paint surface beautifully recreates the suffused light on the scene.

43

GOUACHE PALETTE

As with the basic watercolour palette, this selection of colours will enable you to discover the basic characteristics of gouache paints. The selection may then be augmented by further colours from the range available, depending on the subjects you wish to paint.

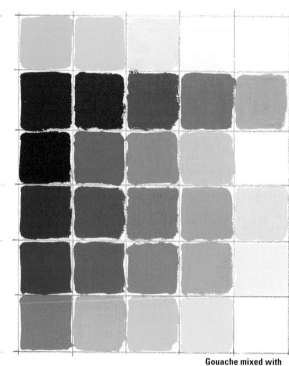

Gouache mixed with water

Gouache mixed with permanent white

Starting selection, from top to bottom

Cadmium yellow
Permanence excellent (ASTM I).
Lemon shades through to warm orange.
Mixes well, forming strong greens when mixed with viridian.

Cadmium red
Permanence excellent (ASTM I).
Warm orange-red to deep red.
A strong, pure pigment, excellent in mixes.

French ultramarine
Permanence excellent (ASTM I).
Deep blue with a slightly violet tinge.
When mixed with yellows, provides a useful, versatile range of greens.

Raw umber
Permanence excellent (ASTM I).
Brown with a slightly greenish-brown tinge.
Good for neutralizing other colours.

Viridian
Permanence excellent (ASTM I).
Cool, bluish green.
Retains its brilliance, even in mixes.

Yellow ochre
Permanence excellent (ASTM I).
Soft, golden yellow.
Tones down brighter colours in mixes.

Starting selection

All manufactured gouache colours are opaque and have a high degree of permanence; a starting selection is shown right. The colours can be intermixed and thinned with water (above left) to create transparent colours which look similar to true watercolour paint or mixed with white paint (above right) to create opaque tints.

The ASTM (American Society for Testing and Materials) codes for lightfastness:

ASTM I – excellent lightfastness
ASTM II – very good lightfastness
ASTM III – not sufficiently lightfast

• Permanent white
Permanence good (ASTM II).
Cool white with good covering power.
Include this colour in your starter palette.

Edward McKnight Kauffer (1890-1954)
UNTITLED LITHO PRINT, 1919
75 x 112cm (30 x 44¾in)
Museum of Modern Art, New York

Posters were traditionally painted on board or stretched paper with gouache, tempera or cheap and impermanent 'poster colours'. Gouache colours were the first choice of graphic designers and commercial artists for many years. Their strong colour and solid, velvety, non-reflective surface finish photograph well, enabling artwork to be converted accurately to print.

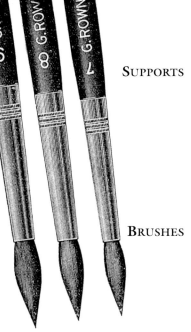

SUPPORTS

Since gouache is opaque, the translucency of white paper is not as vital as it is in watercolour, so it can be applied to a wide variety of supports. Lightweight papers should be avoided; the paint film of gouache is thicker than that of watercolour, and is liable to crack if used on a too-flimsy support. Gouache can also be used on surfaces such as cardboard, wood or primed canvas, so long as they are free from oil. You can also employ toned and coloured papers, as used for pastel work.

BRUSHES

Watercolour brushes are normally used for gouache painting, though bristle brushes are useful for making textural marks. However, because gouache does not handle in the same way as watercolour, experiment to determine which type and size of brush best suits your technique.

Geraldine Girvan
PLUMS IN A GREEN DISH
Gouache on paper
40 x 30cm (16 x 12in)
Chris Beetles Gallery, London

This artist revels in the bright colours and strong patterns found in both natural and man-made objects. She finds that gouache is the perfect medium to give her the fluidity and richness suited to her interpretation of the subject.

Using toned paper
This can be highly effective; the surface acts as a mid-tone from which to work up to the lights and down to the darks, and also helps to unify elements of composition (see sketch below). If you intend leaving areas of the paper untouched, however, make sure you choose a good-quality paper which will not fade.

John Martin
UNTITLED SKETCH
(above)
Gouache on tinted paper
10 x 15cm (4 x 6in)

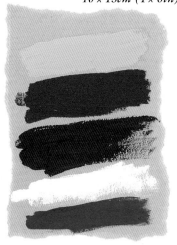

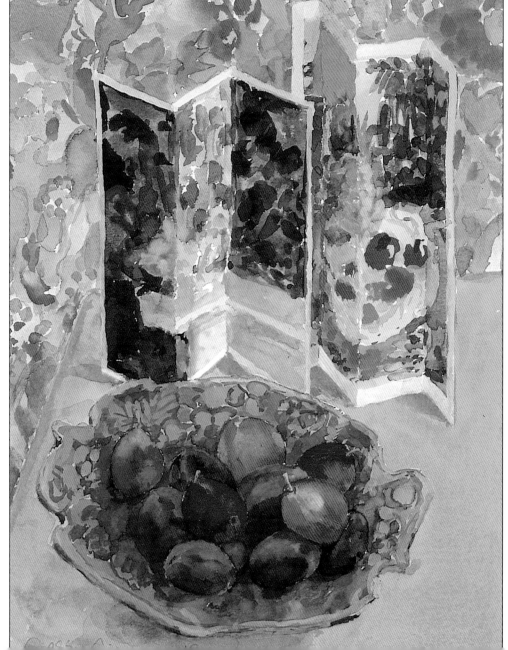

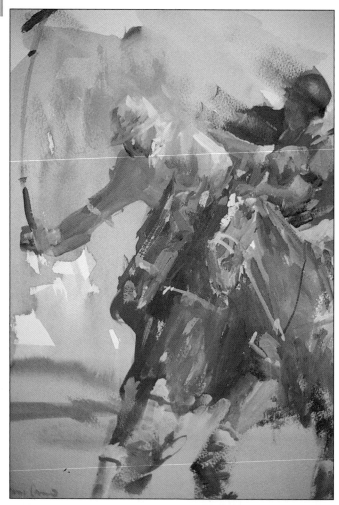

Jane Camp
LAST CHUKKA
Gouache on paper
35 x 25cm (14 x 10in)
Westcott Gallery, Dorking

This is a marvellous example of the fluid and vigorous use of gouache to convey movement and energy. The beauty of the medium is its inherent ability to create appropriate textural marks, almost of its own free will.

Sally Keir
RED POPPIES
Gouache on paper
24 x 26.5cm (9⅜ x 10⅜in)

Although lacking the luminous effect of pure watercolour, gouache has a brilliant, light-reflecting quality that is ideally suited to flower studies. This painting has all the clarity and detail of botanical illustration, but the vibrant intensity of gouache colours keeps the subject alive in a way which many detailed flower paintings fail to do.

Making and using gouache impasto
The impasto technique is usually associated with oil or acrylic painting, but the addition of impasto gel turns gouache or watercolour paint into a thick, malleable paste. Mix the gel approximately half-and-half with the paint, and apply to the support with a knife or a brush to make textured effects.

TECHNIQUES

Gouache is a somewhat underrated painting medium, considering how versatile it is. Like watercolour, it can be thinned with water to a fluid consistency, but its relative opacity gives it a more rugged quality, ideal for bold, energetic paintings and rapid landscape sketches. When wet, gouache can be scrubbed, scratched and scumbled, and interesting things happen as colours run together and form intricate marbled and curdled patterns.

WASHES AND TONES

Gouache is equally suitable for a more delicate, lyrical style of painting, in which washes of thin, semi-transparent colour are built up in layers which dry with a soft, matt, velvety appearance.

With gouache colours, tones may be lightened either by adding white or by thinning the paint with water, depending on the effect you wish to achieve. Thinning with water gives gouache a semi-opaque, milky quality, while adding white gives a dense, opaque covering.

PAINTING DARK-OVER-LIGHT

Gouache is technically an opaque paint, so you can, in theory, apply light colours over dark. In practice, though, it is best to stick to the dark-over-light method, as gouache is not as opaque as oils or acrylics – in fact some colours are only semi-opaque. Gouache will completely cover a colour if used very thick and dry, but this is not advisable, as it may lead to subsequent cracking of the paint surface.

SOLUBILITY

Because gouache colours contain relatively little binder, they remain soluble when dry, so an application of wet colour may pick up some colour from the layer below. This can be prevented by allowing one layer to dry completely before applying the next. Apply the paint with a light touch, and avoid overbrushing your colours.

Using white
There are two whites available: permanent white (sometimes called titanium white) and zinc white. Permanent white has the greater covering power; zinc white is cool and subtle.

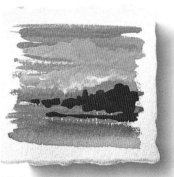

Added white

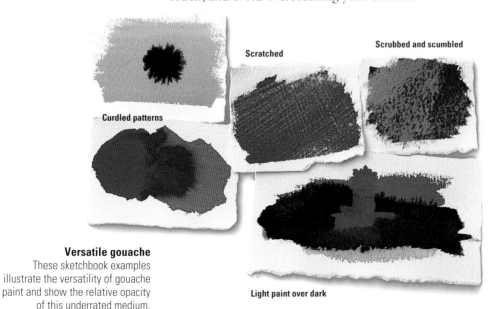

Scratched

Scrubbed and scumbled

Curdled patterns

Light paint over dark

Versatile gouache
These sketchbook examples illustrate the versatility of gouache paint and show the relative opacity of this underrated medium.

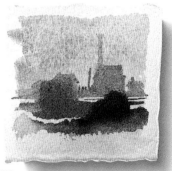

Thinned with water

Lightening tones
The above examples demonstrate how gouache colours can be modified by adding either water or white paint.

EGG TEMPERA

Egg-tempera paint has a long and venerable history, and was universally used until the fifteenth century. Then a method of mixing oils into tempera pigments, to give them greater flexibility, eventually produced a pure oil medium which supplanted tempera.

PAINTS

Tempera is a water-based paint made by mixing egg yolk with pigments and distilled water. As this mixture dries on the painting surface, the water evaporates, leaving a hard, thin layer of colour which is extremely durable.

Prepared egg-tempera colours are available from a few manufacturers, although formulations vary. Daler-Rowney, for example, produce a range of egg-tempera paints, based on a nineteenth-century recipe for an emulsion made from egg yolk and linseed oil. The oil makes the paint slower-drying, more flexible and easier to manipulate, yet it remains water-thinnable. However, because the colour range of ready-made paints is limited, many artists working in tempera prefer to prepare their own paints, using the vast range of colour pigments available.

Pigments
Commercial colour pigments suitable for making tempera paints can be purchased from art shops.

Basic palette
Manufactured-tempera colours are all relatively transparent, and all have a high degree of permanence. The colours cannot be mixed on the support. A starting selection would be similar to that described for gouache, but the technique for building up tones with small strokes (see right) means that the artist will develop a personal palette, depending on the subjects chosen.

The ASTM (American Society for Testing and Materials) codes for lightfastness:

ASTM I – excellent lightfastness
ASTM II – very good lightfastness
ASTM III – not sufficiently lightfast

Titanium white
Permanence excellent (ASTM I). Include this colour in your palette

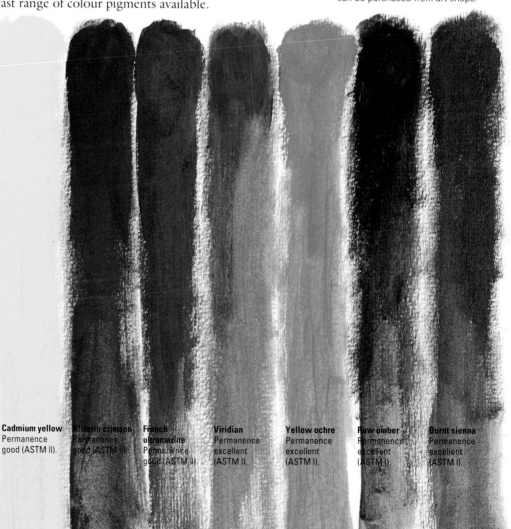

Cadmium yellow
Permanence good (ASTM II).

Alizarin crimson
Permanence good (ASTM II).

French ultramarine
Permanence good (ASTM II).

Viridian
Permanence excellent (ASTM I).

Yellow ochre
Permanence excellent (ASTM I).

Raw umber
Permanence excellent (ASTM I).

Burnt sienna
Permanence excellent (ASTM I).

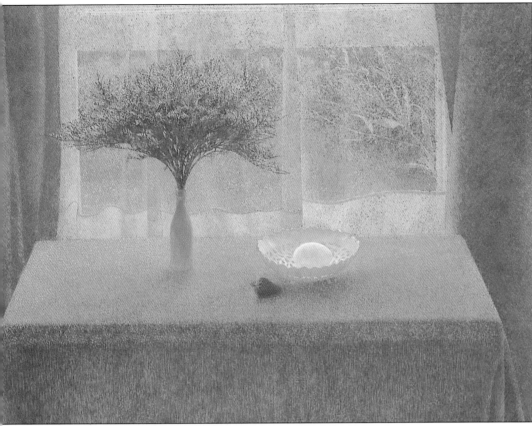

David Tindle
STRAWBERRY
Egg tempera on board
58.5 x 81.3cm (23⅜ x 32½in)
Fischer Fine Art, London

As a painter in the quiet, Romantic tradition, David Tindle is concerned with small, intimate, domestic subjects. He uses pure egg tempera and a delicate and painstaking application of tiny hatched marks to portray the disembodying effect of light filtered through a curtained window, reducing solid objects to veils of luminous tone.

TECHNIQUES

Tempera is not a spontaneous medium, but is suited to artists who enjoy using a meticulous technique. The paint dries within seconds of application, so colours cannot be blended on the support as they can with other media. Instead, tones and colours are built up with thin colour applied in glazes, or with tiny, hatched strokes. Any number of coats can be superimposed without the finished painting losing any of its freshness. Indeed, repeated layers of translucent colour enhance, rather than diminish, the luminous clarity of tempera.

DIFFERENT 'TEMPERAS'

Tempera paints are no longer made exclusively with egg, so the term tempera has also come to cover emulsions of various sorts. Some paint manufacturers on the European continent, for example, refer to their gouache paints as 'tempera', so check carefully before buying.

SURFACES

Tempera can be used on a wide variety of supports, including canvas panels and paper, but the traditional ground is gesso-primed board, where the smooth, brilliant-white surface reflects light back through the paint, giving the colours extraordinary luminosity.

UNDERPAINTING FOR OILS

Tempera also makes a wonderful underpainting for oils. Applied to a white ground, the colour gleams through each layer, giving a painting a deep, luminous glow.

• Brushes
Round sables or synthetics with a good point are the best brushes for tempera painting. The long-haired varieties, such as riggers and lettering brushes, are the most suitable; they hold more colour and can be worked for longer than short-haired brushes. As tempera dries quickly, brushes must be washed frequently in distilled or boiled water.

WATERCOLOUR PAPERS

A well-known professor of painting used to say that no artist really succeeds until he has found his paper. Today there are plenty of excellent watercolour papers to choose from, and it is well worth experimenting in order to find the one that best responds to your working method.

PAPER PRODUCTION

There are three ways of producing watercolour paper: by hand; on a mould machine; and on a fourdrinier machine.

Handmade paper

The very best papers are made of 100 per cent cotton, and are usually made by skilled craftsmen. Handmade papers are lively to use, durable, and have a pleasing irregular texture. They are expensive, but worth the cost.

Mould-made paper

European mills produce paper on cylinder-mould machines. The paper fibres are formed into sheets with a random distribution, close to that of handmade papers. The paper is durable, extremely stable, and resistant to distortion under a heavy wash.

Machine-made paper

Although inexpensive to produce and to purchase, machine-made papers are less resistant to deterioration, but may distort when wet. Some papers also have a mechanical, monotonous surface grain.

CHOOSING PAPER

Watercolour paper is an excellent surface for acrylics, pencil, ink, gouache and pastel, as well as watercolour. The character of the paper, and its surface texture, play a vital role in the finished picture. Very often it is the choice of paper that is to blame for a painting going wrong, rather than any inadequacy on the part of the artist.

Some papers are superior in quality to others, but it does not necessarily follow that an expensive paper will give better results. The important thing is to find a paper that is sympathetic to what you want to do. It is no good using an absorbent rag paper if your technique involves repeated scrubbing, lifting out and using masking fluid; the surface soon becomes woolly and bruised.

Popular papers are available in local art shops. Specialist art shops stock less-common and handmade or foreign papers; some of these are also available mail-order direct from the mill or through distributors, who can send sample swatches, price lists and order forms.

Once you have settled on a favourite paper, it pays to buy in quantity. The bigger the order, the more you save.

Try before you buy
Trial and error can be a costly affair, given the price of the average sheet of watercolour paper. However, most paper manufacturers produce swatches or pochettes – booklets containing small samples of their ranges. These provide an excellent and inexpensive means of trying out several types of paper.

• Paper sizes
Sizes of papers differ from country to country, and it is still common practice for art suppliers to describe paper in imperial sizes. The following table is a guide to imperial sizes and their metric equivalents.

Medium
22 x 17½in (559 x 444mm)

Royal
24 x 19in (610 x 483mm)

Double Crown
30 x 20in (762 x 508mm)

Imperial
30½ x 22½in (775 x 572mm)

Double Elephant
40 x 26¼in (1016 x 679mm)

Antiquarian
53 x 31in (1346 x 787mm)

Texture

There are three different textures of watercolour paper: (from top to bottom) hot-pressed or HP (smooth), Not or cold-pressed (medium grain) and rough. Each manufacturer's range is likely to have a slightly different feel.

Hot-pressed paper

Hot-pressed paper has a hard, smooth surface suitable for detailed, precise work. Most artists, however, find this surface too smooth and slippery, and the paint tends to run out of control.

Cold-pressed paper

This is also referred to as 'Not', meaning not hot-pressed. It has a semi-rough surface equally good for smooth washes and fine brush detail. This is the most popular and versatile of the three surfaces, and is ideal for less-experienced painters. It responds well to washes and has enough texture to give a lively finish.

Rough paper

This has a more pronounced tooth (tiny peaks and hollows) to its surface. When a colour wash is laid on it, the brush drags over the surface and the paint settles in some of the hollows, leaving others untouched. This leaves a sparkle of white to illuminate the wash.

Experimenting with watercolour papers

Try out different textures and makes of watercolour paper until you find one which suits your painting style. As you become more knowledgeable you will also be able to choose a paper to suit your subject.

In these examples, the artist has chosen a smooth texture for the nude study (top), which is perfectly appropriate for the tone and texture of the flesh. The winter-evening snow scene (centre) is perfectly suited for a medium-texture paper which conveys the effect of misty light and captures the subtle grain of the snow. A rough-texture paper (below) communicates the solidity of the building and the dampness of the weather to the viewer.

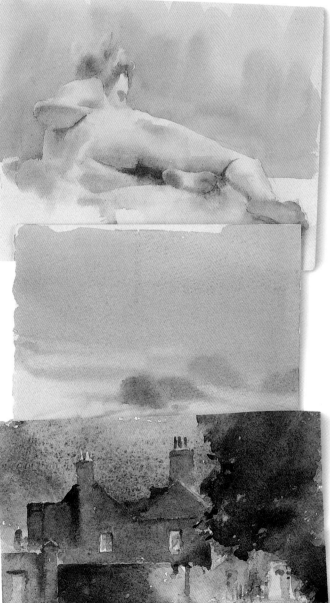

Smooth-texture paper

Medium-texture paper

Rough-texture paper

Trevor Chamberlain
(from top to bottom)
RECLINING NUDE
SNOW, LATE-EVENING EFFECT
SHOWERY EVENING,
ISLEWORTH
All watercolour on paper
Various dimensions

Choosing watercolour papers

Choice of watercolour papers is very much a matter of personal preference; one artist's favourite may be another artist's poison. The chart below is intended only as a guide to a versatile selection of widely available papers. They have all been tried and tested by professional watercolour artists; however, your own assessment may be quite different.

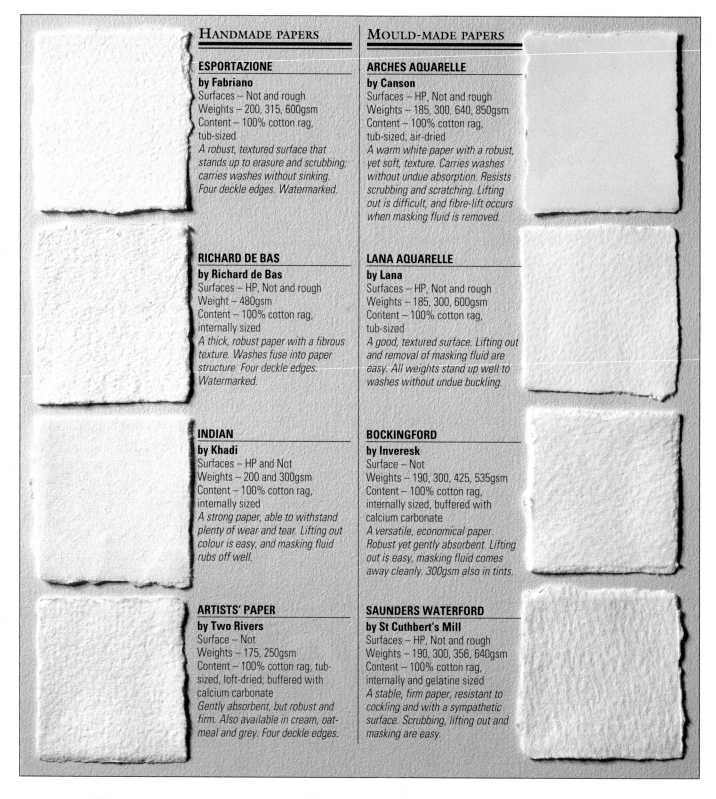

HANDMADE PAPERS

ESPORTAZIONE
by Fabriano
Surfaces – Not and rough
Weights – 200, 315, 600gsm
Content – 100% cotton rag, tub-sized
A robust, textured surface that stands up to erasure and scrubbing; carries washes without sinking. Four deckle edges. Watermarked.

RICHARD DE BAS
by Richard de Bas
Surfaces – HP, Not and rough
Weight – 480gsm
Content – 100% cotton rag, internally sized
A thick, robust paper with a fibrous texture. Washes fuse into paper structure. Four deckle edges. Watermarked.

INDIAN
by Khadi
Surfaces – HP and Not
Weights – 200 and 300gsm
Content – 100% cotton rag, internally sized
A strong paper, able to withstand plenty of wear and tear. Lifting out colour is easy, and masking fluid rubs off well.

ARTISTS' PAPER
by Two Rivers
Surface – Not
Weights – 175, 250gsm
Content – 100% cotton rag, tub-sized, loft-dried; buffered with calcium carbonate
Gently absorbent, but robust and firm. Also available in cream, oatmeal and grey. Four deckle edges.

MOULD-MADE PAPERS

ARCHES AQUARELLE
by Canson
Surfaces – HP, Not and rough
Weights – 185, 300, 640, 850gsm
Content – 100% cotton rag, tub-sized, air-dried
A warm white paper with a robust, yet soft, texture. Carries washes without undue absorption. Resists scrubbing and scratching. Lifting out is difficult, and fibre-lift occurs when masking fluid is removed.

LANA AQUARELLE
by Lana
Surfaces – HP, Not and rough
Weights – 185, 300, 600gsm
Content – 100% cotton rag, tub-sized
A good, textured surface. Lifting out and removal of masking fluid are easy. All weights stand up well to washes without undue buckling.

BOCKINGFORD
by Inveresk
Surface – Not
Weights – 190, 300, 425, 535gsm
Content – 100% cotton rag, internally sized, buffered with calcium carbonate
A versatile, economical paper. Robust yet gently absorbent. Lifting out is easy, masking fluid comes away cleanly. 300gsm also in tints.

SAUNDERS WATERFORD
by St Cuthbert's Mill
Surfaces – HP, Not and rough
Weights – 190, 300, 356, 640gsm
Content – 100% cotton rag, internally and gelatine sized
A stable, firm paper, resistant to cockling and with a sympathetic surface. Scrubbing, lifting out and masking are easy.

PAPER CONTENT

Apart from water, the main ingredient in making paper is cellulose fibres, derived from either cotton or woodpulp. Cotton is used for high-grade papers, woodpulp for others. Some papers contain a blend of cotton and other cellulose fibres, offering a compromise between cost and quality.

Increasing sizing
If paper is too absorbent, paint sinks into it and colours appear dull. To remedy this, dissolve a teaspoon of gelatin granules in half a litre (1.1pints) of water and apply to the surface before painting.

• Acid content
Papers that contain an acid presence, such as newsprint and brown wrapping paper, are prone to yellowing and deterioration in time. Paper acidity is measured by the pH scale. An acid-free paper does not contain any chemicals which might cause degradation of the sheet, and normally has a pH of around 7 (neutral). All good-quality watercolour papers are acid-free, to prevent yellowing and embrittlement with age. Some are also buffered with calcium carbonate, to protect against acids in the atmosphere.

Cotton rag
The best paper is made from 100 per cent cotton. Although the term 'rag paper' is still used, the raw material nowadays is natural cotton linters. Rag papers are very strong, yet pliable, and withstand demanding techniques.

Woodpulp
Woodpulp produces a more economical, but less durable, paper. Confusingly, papers made of 100 per cent woodpulp are sometimes advertised as 'woodfree'; this is a technical term meaning wood broken down by chemical means, rather than mechanical ones – it does not signify that the paper has not been made from wood.

Mechanical woodpulp still contains lignin, which releases acids into the paper over a period of time, causing it to yellow and embrittle. The chemical woodpulp used in woodfree paper is processed to remove all the lignin.

Reducing sizing
If a heavily sized paper does not take paint well, pass a damp sponge over the surface several times. Leave for 30 minutes, then dampen again before painting. Some hand-made papers may need to be soaked for up to two hours in warm water.

WEIGHT

The weight (thickness) of watercolour paper traditionally refers to the weight of a ream (500 sheets) of a given size, most often imperial (about 22 x 30in or 56 x 76cm). For instance, a 72lb paper is a light paper, 500 sheets of which weigh 72lb. However, the more accurate metric equivalent of grammes per square metre (gsm) is now common.

Lighter papers (less than 300gsm/140lb) tend to buckle and wrinkle when washes are applied, and need to be wetted and stretched on a board before use. Heavier grades don't need to be stretched unless you intend to flood the paper with washes.

Weights of watercolour paper

Metric	Imperial
150gsm	72lb
180gsm	90lb
300gsm	140lb
410gsm	200lb
600gsm	300lb
850gsm	400lb

ABSORBENCY AND SIZING

All watercolour paper is internally sized to varying degrees, to control its absorbency and produce a more receptive working surface. Heavy sizing produces a hard surface with little absorption and a long drying time; this allows you to push the paint around on the surface, and colours remain brilliant, as they are not dulled by sinking into the paper. Lightly sized papers are softer and more absorbent, with a shorter drying time. Alterations are more difficult because the paint sinks into the fibres of the paper, but absorbent papers are suited to direct, expressive painting methods.

Internal sizing
Internal, or 'engine', sizing means that the size is added to the paper at the pulp stage, and is contained in the body of the paper. Internal sizing renders the paper robust and prevents colour washes from cross-bleeding beneath the paper surface, even when it has been abraded.

Trying for size
The amount and quality of sizing varies according to the brand of paper. A quick test is to lick a corner of the paper with the end of your tongue: if it feels dry and sticks to your tongue, it is absorbent paper.

Surface sizing

Many watercolour papers are also surface-sized by being passed through a tub of gelatin size (hence the term 'tub-sized'). Surface sizing reduces the absorbency of the paper and produces a more luminous wash (on absorbent papers, colours tend to dry far paler than they appear as a wet wash). It also reduces the risk of fibre lift when removing masking material and lifting out washes of colour.

WATERCOLOUR SHEETS Watercolour paper is most commonly sold in sheet form. In addition, many mills supply their papers in rolls, which are more economical, and pads.

WATERCOLOUR BLOCKS These comprise sheets of watercolour paper which are 'glued' together round the edges with gum. This block of paper is mounted on a backing board. A watercolour block removes the need for stretching paper. When the painting is completed, the top sheet is removed by sliding a palette knife between the top sheet and the one below. Although more expensive than loose sheets, watercolour blocks are convenient and time-saving.

Spiral pads
Watercolour paper also comes in the form of spiral-bound pads, which are convenient for outdoor sketching. They generally contain 300gsm (140lb) Not paper.

WATERCOLOUR BOARDS Watercolour board is another way of avoiding stretching paper. It consists of watercolour paper mounted onto a strong backing board to improve its performance with heavy washes.

THE VITAL SURFACE A work of art on paper is an intimate object, in which there is a dialogue between the surface and the marks made on it. Watercolour paper often comes in sheets with uneven deckle edges; these ragged edges are often left on the finished painting, being integral to the visual effect.

TINTED PAPERS Most watercolour paper is white or off-white, to reflect the maximum amount of light back through the transparent washes of colour. However, some manufacturers specialize in tinted papers, and these are often used when painting with body colour or gouache.

Always check that the tinted paper you buy is sufficiently lightfast. Good-quality papers will not fade under normal conditions, but cheaper paper may not be as permanent as the colours laid on it, and in time the change could affect the overall tone of your painting.

Many artists prefer to apply their own tint by laying a very thin wash on white paper.

Tints and shades
Papers suitable for watercolour painting also come in a variety of colours.

STRETCHING PAPER

Wet paint causes the fibres in watercolour paper to swell, and this can lead to buckling, or 'cockling' of the surface. To avoid this, stretch paper before starting to work on it.

ACHIEVING A SMOOTH PAINTING SURFACE

The paper is wetted and then securely taped to a board. On drying, it contracts slightly and becomes taut, giving a smooth surface that is less prone to cockling.

With heavier papers (300gsm and over) there is less need for stretching, unless heavy, saturated washes are to be applied. Lighter papers always need stretching.

Method
Cut four lengths of gummed brown-paper tape 50mm (2in) longer than the paper. Do this first, to avoid panic at the crucial moment, when wet hands, crumpled tape and a rapidly curling sheet of paper could cause chaos.

Immerse the paper in cold water for a few minutes (**1**), making sure it has absorbed water on both sides; heavier papers may take up to 20 minutes Use a container large enough to take the sheet without being cramped. For large sheets, use a clean sink or bath.

Immerse only one sheet at a time in fresh water, as each sheet will leave a residue of size in the water.

Hold the paper up by one corner and shake it gently to drain surplus water. Place the paper onto the board (**2**) and smooth it out from the centre, using your hands, to make sure that it is perfectly flat.

Take a dry sponge around the edges of the paper where the gummed tape is to be placed, to remove excess water (**3**). Moisten each length of gum strip with a damp sponge immediately before use. Beginning with the long sides, stick the strips around the outer edges of the paper, half their width on the board, half on the paper (**4**).

Leave the paper to dry flat, allowing it to dry naturally, away from direct heat. Do not attempt to use stretched paper until it is dry. Leave the gummed strips in place until the painting is completed and dry.

Commercial paper stretchers
For artists who find stretching paper a time-consuming chore, the only previous alternative has been to use expensive heavyweight papers or boards. However, there are now various effective devices available, designed by watercolour painters, which will stretch lightweight papers drum-tight in minutes. Among the ingenious designs, one uses a two-piece wooden frame to hold the paper firmly in place as it dries; another employs a system of plastic gripper rods which are pushed into grooves in the edges of the board, to hold the paper.

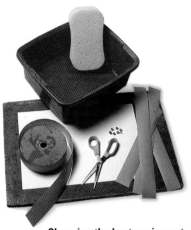

Choosing the best equipment
Use only gummed brown-paper tape for stretching paper – masking tape and self-adhesive tape will not adhere to damp paper. A clean wooden drawing board is the ideal surface for stretching paper – traces of paint or ink might stain the paper. Plastic-coated boards are not suitable, because gummed tape will not stick to them.

• Immersion times
These depend on the weight and degree of surface sizing of the paper. Thin paper soaked for too long will expand greatly, and may tear as it contracts; too brief an immersion means the paper will not expand enough, and will buckle when wet paint is applied. The correct soaking time for each paper will come through trial and error, but in general lightweight papers and those not strongly sized should be soaked for 2-3 minutes; heavily sized papers may need 5-10 minutes. (If a fine layer of bubbles appears when the paper is immersed, this indicates a strongly sized paper.)

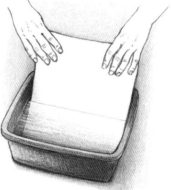

(1) Immersing the paper

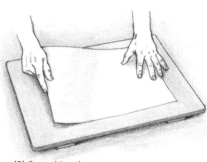

(2) Smoothing the paper

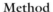

(3) Removing excess water

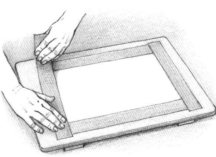

(4) Sticking the gummed strip

SKETCHBOOKS

Despite the ubiquitous camera, most artists still prefer to carry a sketchbook and pencil with them. Because a sketch is the immediate result of observation, capturing a personal impression in a few essential strokes, it is an absolutely vital adjunct to, and preparation for, more considered studio work.

KEEPING A SKETCHBOOK

A sketchbook is an artist's most valuable piece of 'equipment'. It is the perfect place in which to improve your drawing skills and powers of observation, and to develop new ideas. It is also a place to note and record anything of interest, and as such becomes a valuable storehouse of visual references.

A sketchbook also helps to build up your confidence; rapid and frequent sketching aids you to express more intuitively what you feel and see. With a sketchbook and pencil, you can catch life on the wing.

ANYTHING GOES

A chance arrangement of objects on the breakfast table, a transitory effect of light; anything can be noted down rapidly and later used as the basis for a later composition – or simply for the sheer joy of observing and recording something pleasurable to the eye.

THE ARTISTIC PROCESS

The most interesting aspects of the work of any artist are often to be found, not in their finished paintings, but in their sketchbook drawings. Artists talk to themselves in the candour of their sketches, leaving immediate impressions as they jot down their reactions to the world around them.

For the onlooker, there is a fascination in looking at sketches, because it helps us to understand how that mysterious creature, the artist, actually comes by and shapes his or her inspiration. There is also, perhaps, a fascination with the unfinished rather than the complete, which appeals to the romantic in all of us.

Sketching easels
The tripod-style sketching easel is lightweight and easily portable, and is suitable both for outdoor work and for small-scale work indoors. Available in aluminium and wood, it has telescopic legs to enable you to work at a convenient height, and the pivoted central section can be tilted to a horizontal position. It can be folded away when not in use.

Richard Bell, David Day, Simon Jennings, Anna Wood
SKETCHBOOKS *(below and opposite)*
Various watercolour and drawing media on paper

These collages of artists' sketchbooks show the sheer variety of styles, occasions and intentions to be found. Each is different, and each is a document of one particular creative moment.

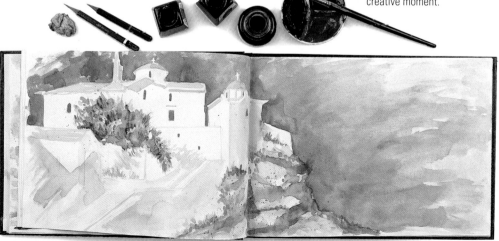

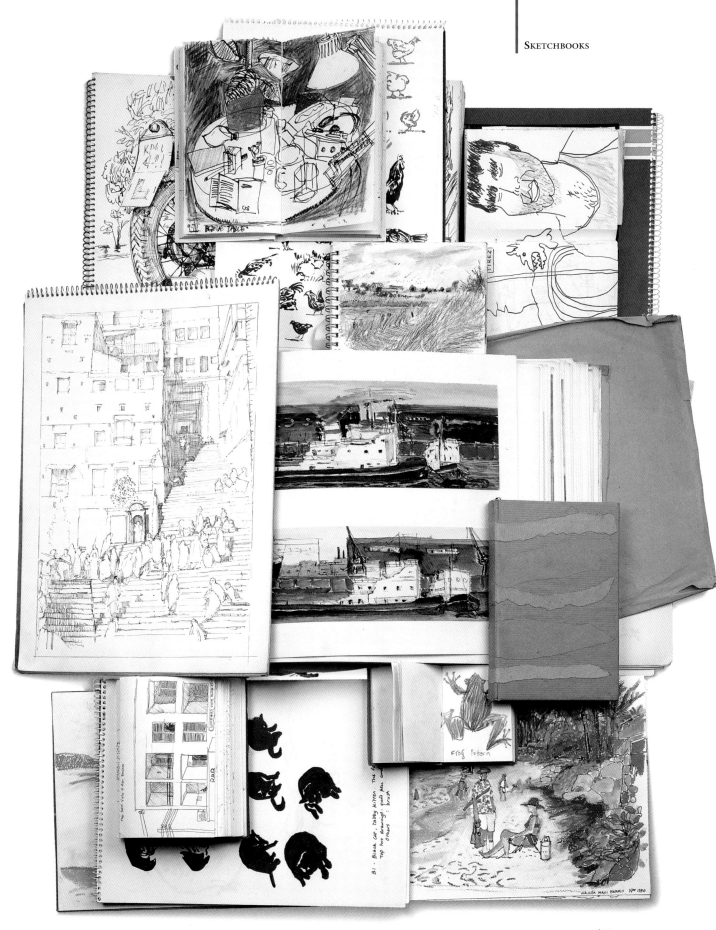

PROTECTING ARTWORK

All too often, pictures are stored in damp basements or leaking attics, or hung in rooms with inappropriate or harmful lighting. They are often displayed or stored away without any means of protection. A few simple precautions can do much to preserve your pictures in the best possible condition – having laboured with love and time on an artwork, it makes sense to look after it.

Unframed pictures
Pictures that you want to keep, but not frame, should be stored in a safe place, such as a portfolio or plan chest.

AVOIDING DAMP, LIGHT AND HEAT

Keep all artworks away from damp and humid conditions, which encourage mildew, and also from excessively dry conditions. In addition, avoid extreme temperature changes, such as those caused by room heaters, radiators or draughty windows.

Some of the greatest damage to pictures is done by strong, direct light, which can fade colours and discolour varnishes. In strong sunlight, or under spotlights, heat can be equally damaging, so display your pictures, particularly works on paper, away from direct sunlight and in diffused artificial lighting.

(1) Cut out four shapes.

STORING WATERCOLOURS AND DRAWINGS

Unmounted watercolours and drawings should not be left unprotected for long, and should be stored in a safe place until such time as you can have them framed. They should be stored flat in large drawers or a plan chest, or at least in a portfolio, interleaved with sheets of waxed paper, cellophane or acid-free tissue, to prevent them rubbing together and becoming smudged. A heavy board laid on top will prevent any lateral movement. Do not stack too many drawings on top of each other, as this may compact and damage the surface pigment.

It is not a good idea to roll up and store drawings that have not had fixative applied (see opposite), as the pigments tend to drop off or smudge.

(2) Fold the flaps.

TRANSPORTING PAINTINGS

If you need to transport framed paintings, you should protect the corners of the frames by padding them out with plastic foam or bubble-wrap, or with cardboard sleeves. This will also prevent the paintings leaning flat against each other in storage.

To make cardboard sleeves, cut out four shapes as shown (**1**), making the space between the parallel dotted lines slightly larger than the width of the frame. Fold flaps A and B and tape them closed (**2**). Fit the sleeves over each corner and tape them to the backing or glass (not the frame, as it may damage any surface decoration) to keep them in place (**3**).

(3) Fit and secure the sleeves.

PROTECTING DRAWINGS

Drawings executed in a friable medium, such as charcoal, pastel, conté crayon and chalk, are easily smudged; and when they are framed, there is a danger of pigment particles drifting down under the glass and soiling the mount board.

FIXATIVE

• Protecting oil-pastel drawings
Unlike other pastels, oil pastels do not require fixing, because the blend of pigments, fat and and wax never fully dries. For this same reason, it is inadvisable to apply varnish over oil pastels; should you need to remove the varnish at a later date, it will take most of the oil-pastel colour off the surface with it. The most effective and lasting protection is to mount oil-pastel drawings under glass.

To prevent these problems, this kind of drawing should be protected with fixative. This is a thin, colourless varnish which is sprayed onto the picture and fixes the pigment particles to the surface. It is most commonly available in aerosol spray cans, which are the most convenient method to use. Alternatively, there are mouth diffusers which have a plastic mouthpiece, through which you steadily blow a fine mist of fixative.

Spraying a drawing with fixative requires a delicate touch; it should be applied sparingly, as a couple of light coats are better than one heavy one. It is worth practising on pieces of scrap paper until you discover how to produce a fine, uniform mist without getting any drips on the paper. If you hold the spray too close, it will saturate the surface and may run and streak your work.

Always work in a well-ventilated area, to avoid inhaling too much of the spray.

Mouth diffusers
These have a plastic mouthpiece through which fixative is blown.

Spraying directions

Applying fixative

Pin your finished work vertically and hold the atomizer at least 30cm (12in) away from the image, pointing directly at it. Begin spraying just beyond the left side of the picture. Sweep back and forth across the picture with a slow, steady motion, always going beyond the edges of the picture before stopping (see right). Keep your arm moving so that the spray doesn't build up in one spot and create a dark patch or start to drip down the paper.

Protective framing
The way you present artwork not only displays it to best advantage but also protects it from pollutants and accidental damage. Below, the drawing is hinged from the top edge only, within a folded bookmount that holds the glass at a safe distance. A stiff backing board of hardboard or MDF keeps the drawing flat.

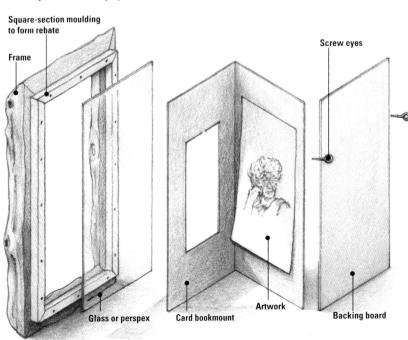

Square-section moulding to form rebate

Frame

Screw eyes

Glass or perspex

Card bookmount

Artwork

Backing board

HEALTH AND SAFETY

Manufacturers of art materials pay a great deal of attention to current safety legislation; most manufacturers' catalogues provide reasonably detailed information on safety, toxicity and the like, and the products themselves are generally clearly labelled (see left).

However, safety legislation differs from country to country, and there is no single international classification for all art materials, which basically means that a substance regarded as hazardous to health may be withdrawn or substituted in one country but not another, depending on the legislation.

Some of the most determined opposition to changes in the composition of paint has come from artists who fear that modern substitutes cannot give them the same results as traditional (but possibly more hazardous) pigments, such as cadmiums, lead chromes or cobalts. Manufacturers, however, put a vast amount of time, money and research into finding alternative materials that approximate the original as closely as possible, in order to comply with ever-more-stringent laws.

In the end, the decision of what to use and how to use it must be made by each individual artist, and the best way to work safely is to be well informed about the materials you are using. Read the catalogues, check the labelling, and don't be afraid to contact the manufacturers if you are concerned about a product's safety or quality.

Above all, follow the manufacturer's instructions where printed. Making art is many things – creative, fun, inspiring, frustrating – but it need not be hazardous to your health.

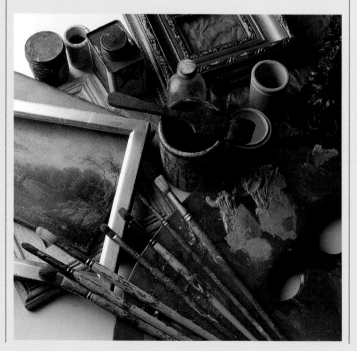

Highly flammable
Products bearing this international label have a flash point of below 21°C. The containers should be kept closed when not in use, and should not be left near sources of heat or ignition. Do not breathe the vapour or spray, and keep the product away from children.

Harmful/Irritant
This international label is used to mark products classified as either harmful or irritant; each classification has its own particular warnings. In both cases, do not breathe the vapour, and keep the product away from children. Avoid contact with skin and eyes, and wash thoroughly after use.

Health label (HL)
This American label, from the Art and Craft Materials Institute (ACMI), means that the product has been reviewed by an independent toxicologist under the auspices of the American Society for Testing and Materials (ASTM).

CP
An American label, again from the ACMI. 'CP' stands for Certified Product, in which the contents are non-toxic, even if ingested, and which meet or exceed specific quality standards.

AP
Another American label from the ACMI, 'AP' means Approved Product, one where the contents are non-toxic, even if ingested.

Interpreting labels
These are the hazard labels you are likely to see on art products. Familiarity with their meanings will enable you to evaluate standards and possible hazardous use at a glance, and to use and store materials with minimum risk.

Reading a paint tube

It is well worth knowing the characteristics – permanence, lightfastness, transparency, and so on – of the paints you use. Although there may appear to be a bewildering amount of coded information on a standard tube of paint, this is actually quite simple to decipher, and the ability to 'read' a tube will help you choose the right paint.

The tube shown below is a composite, but all the information on it can be found on different tubes; each manufacturer's catalogue provides further details particular to its brands.

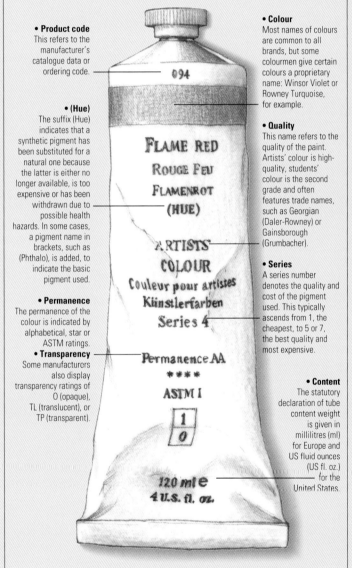

• Product code
This refers to the manufacturer's catalogue data or ordering code.

• (Hue)
The suffix (Hue) indicates that a synthetic pigment has been substituted for a natural one because the latter is either no longer available, is too expensive or has been withdrawn due to possible health hazards. In some cases, a pigment name in brackets, such as (Phthalo), is added, to indicate the basic pigment used.

• Permanence
The permanence of the colour is indicated by alphabetical, star or ASTM ratings.

• Transparency
Some manufacturers also display transparency ratings of O (opaque), TL (translucent), or TP (transparent).

• Colour
Most names of colours are common to all brands, but some colourmen give certain colours a proprietary name: Winsor Violet or Rowney Turquoise, for example.

• Quality
This name refers to the quality of the paint. Artists' colour is high-quality, students' colour is the second grade and often features trade names, such as Georgian (Daler-Rowney) or Gainsborough (Grumbacher).

• Series
A series number denotes the quality and cost of the pigment used. This typically ascends from 1, the cheapest, to 5 or 7, the best quality and most expensive.

• Content
The statutory declaration of tube content weight is given in millilitres (ml) for Europe and US fluid ounces (US fl. oz.) for the United States.

Codes and symbols
In addition to the above, some products carry other coded information to indicate transparency, mixing potential, safety information, and so on. The manufacturer's catalogue gives details.

Glossary of terms

In addition to the many everyday words used to describe art materials and techniques, there are equally as many that are unique. Most of the specialized words and terms used in this book are explained here, plus some others which you will come across in further reading.

Alla prima (Italian for 'at the first') Technique in which the final surface of a painting is completed in one sitting, without underpainting. Also known as *au premier coup.*

Balance In a work of art, the overall distribution of forms and colour to produce a harmonious whole.

Bleeding In an artwork, the effect of a dark colour seeping through a lighter colour to the surface. Usually associated with gouache paint.

Blending Smoothing the edges of two colours together so that they have a smooth gradation where they meet.

Bloom A dull, progressively opaque, white effect caused on varnished surfaces by being kept in damp conditions.

Body colour Opaque paint, such as gouache, which has the covering power to obliterate underlying colour. 'Body' also refers to a pigment's density.

Brushwork The characteristic way each artist brushes paint onto a support, often regarded as a 'signature'; used to help attribute paintings to a particular artist.

Cissing The effect caused when a water-based paint either does not wet the support enough to adhere effectively, or is repelled by the surface. Also known as crawling or creeping.

Cockling Wrinkling or puckering in paper supports, caused by applying washes onto a flimsy or inadequately stretched and prepared surface.

Composition The arrangement of elements by an artist in a painting or drawing.

Diluents Liquids, such as turpentine, used to dilute oil paint; the diluent for water-based media is water.

Earth colours These colours, the umbers, siennas and ochres, are regarded as the most stable natural pigments.

Film A thin coating or layer of paint, ink, etc.

Format The proportions and size of a support.

Fugitive colours Pigment or dye colours that fade when exposed to light. *(See also* lightfast *and* permanence.*)*

Gesso A mixture, usually composed of whiting and glue size, used as a primer for rigid oil-painting supports.

Glaze In painting, a transparent or semi-transparent colour laid over another, different colour to modify or intensify it.

Gum arabic A gum, extracted from certain *Acacia* trees, used in solution as a medium for watercolour paints.

Hue The name of a colour – blue, red, yellow etc. – irrespective of its tone or intensity. *(See also* Reading a paint tube, left.*)*

Landscape format A painting or drawing wider than it is tall. *(See also* portrait format.*)*

Lightfast Term applied to pigments that resist fading when exposed to sunlight. *(See also* fugitive.*)*

GLOSSARY

Local colour The actual colour of an object or surface, unaffected by shadow colouring, light quality or other factors; for instance, the local colour of a carrot is always orange, even with a violet shadow falling across it.

Loom-state Canvas that has not been primed, sized or otherwise prepared beforehand.

Medium This term has two distinct meanings: the liquid in which pigments are suspended, for instance, linseed oil for oil painting, and acrylic resin for acrylic paints (the plural here is mediums). A medium is also the material chosen by the artist for working – paint, ink, pencil, pastel, etc. (the plural in this instance is media).

Opacity The covering or hiding ability of a pigment to obliterate an underlying colour. Opacity varies from one pigment to another.

Palette As well as describing the various forms of holders and surfaces for mixing paint colours, palette also refers to the artist's choice and blends of colours when painting.

Permanence Refers to a pigment's resistance to fading on exposure to sunlight. (*See also* fugitive *and* lightfast.*)

Pigments The colouring agents used in all painting and drawing media, traditionally manufactured from natural sources but now including man-made substances. The word is also used to describe the powdered or dry forms of the agents.

Plein air (French for 'open air') Term describing paintings done outside, directly from the subject.

Portrait format A painting or drawing taller than it is wide. (*See also* landscape format.*)

Primer Applied to a layer of size or directly to a support, this acts as a barrier between paint and support, and provides a surface suitable for receiving paint and mediums.

Proportion The relationship of one part to the whole or to other parts. This can refer to, for instance, the relation of each component of the human figure to the figure itself, or to the painting as a whole.

Reduction The result of mixing colour with white.

Saturation The intensity and brilliance of a colour.

Sgraffito (Italian for 'scratched off') A technique of scoring into a layer of colour with a sharp instrument, to reveal either the ground colour or a layer of colour beneath.

Shade Term for a colour darkened with black.

Sketch A rough drawing or a preliminary draft of a composition, not necessarily to be worked up subsequently. Sketches are often used as a means of improving an artist's observation and technique.

Squaring up A method for transferring an image to a larger or smaller format. The original version is covered with a grid of horizontal and vertical lines, and each numbered square is then copied onto its counterpart on a larger or smaller set of squares on a different support. Also known as gridding up.

Support A surface used for painting or drawing – canvas, board, paper, etc.

Tint Term for a colour lightened with white. Also, in a mixture of colours, the tint is the dominant colour.

Tinting strength The power of a pigment to influence mixtures of colours.

Tone The relative darkness or lightness of a colour, without reference to its local colour.

Tooth The texture, ranging from coarse to fine, of paper, canvas or wood.

Tragacanth A gum, extracted from certain *Astragalus* plants, used as a binding agent in watercolour paints and pastels.

Transparency The state of allowing light to pass through, and of filtering, light.

Value An alternative word for 'tone', 'value' is used mainly in the United States. The term 'tonal value' refers to the relative degree of lightness or darkness of any colour, on a scale of greys running from black to white.

Volume The space that a two-dimensional object or figure fills in a drawing or painting.

Wash A thin, usually broadly applied, layer of transparent or heavily diluted paint or ink.

Wetting agent A liquid – ox gall or a synthetic equivalent – added to watercolour paint to help it take evenly and smoothly on a support.

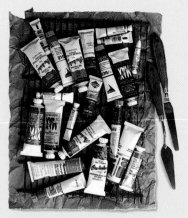

Matière Paint.

Plein air
(French for 'open air') Term describing paintings done outside, directly from the subject.

Scumble
Dryish, opaque paint dragged over another layer of paint so that the underlying colour partially shows through the top one.

INDEX